donations, gifts and sponsorships

The Trustees of the Tate Gallery, The Director of Tate and The Director of Tate Liverpool are indebted to the following for their generous support:

Arrowcroft Group Plc
Arts Council of England
A & B (Arts & Business)
The Abbey National Charitable Trust
The Australian Bicentennial Authority
Barclays Bank PLC
The Baring Foundation
BASF
The Bernard Sunley Charitable Foundation
Bloomberg
Boddingtons plc
British Alcan Aluminium plc
BG plc
BT
Calouste Gulbenkian Foundation
Coopers & Lybrand
Mr & Mrs Henry Cotton
Cultural Relations Committee, The Department
Of Foreign Affairs, Ireland
David M Robinson Jewellery
Deloitte & Touche
DLA
EC Harris
The Eleanor Rathbone Charitable Trust
The John Ellerman Foundation
English Partnerships
The Esmee Fairbairn Charitable Trust
European Arts Festival
European Regional Development Fund
The Foundation for Sport and the Arts
Friends of the Tate Gallery
Girobank plc
The Granada Foundation
Granada Television Limited
The Henry Moore Foundation
The Henry Moore Sculpture Trust
The Heritage Lottery Fund
Mr John Heyman
Higsons Brewery plc
Hitchcock Wright and Partners
Ian Short Partnership
IBM United Kingdom Limited
ICI Chemicals & Polymers Limited
The John Lewis Partnership
The John S Cohen Foundation
The Laura Ashley Foundation
The Littlewoods Organisation PLC

Liverpool John Moores University
Mr & Mrs Jack Lyons
Manchester Airport PLC
Manor Charitable Trust
Merseyside Development Corporation
Marconi
Mobil Oil Company
MOMART Ltd
The Moores Family Charitable Foundation
The Museums and Galleries Improvement Fund
Nigel Moores Family Charitable Foundation
NSK Bearings Europe Ltd
P & P Micro Distributors Ltd
Parkman Group Ltd
P H Holt Charitable Trust
The Pilgrim Trust
Pilkington plc
Pioneer High Fidelity (GB) Ltd
QVC The Shopping Channel
Rio Tinto plc
Royal & SunAlliance
Royal Liver Assurance Limited
Sainsbury Family Charitable Trusts
Samsung Electronics (UK) Limited
Save & Prosper Educational Trust
Scottish Courage Limited
Stanley Thomas Johnson Foundation
Shell Research Ltd
The Summerfield Charitable Trust
Tate Friends Liverpool
Tilney Investment Management
Trinity International Holdings plc
The TSB Foundation for England and Wales
The Trustees of the Tate Gallery
Unilever PLC
United Biscuits (UK) Limited
United Utilities plc
The University of Liverpool
Vernons Pools Ltd
Visiting Arts
Volkswagen
Whitbread & Company PLC
The Wolfson Foundation

1 David Reed

1966, Skowhegan School of Painting and Sculpture, Skowhegan, Maine
1967, New York Studio School, New York
1968, Reed College, Portland, Oregon

Selected Recent Solo Exhibitions
📖 denotes accompanying catalogue

1992
Max Protetch Gallery, New York

1993
Galerie Rolf Ricke, Cologne

1995
David Reed, Kölnischer Kunstverein, Cologne (touring) 📖

1996
Donna Beam Fine Art Gallery, University of Nevada Las Vegas, Las Vegas
New Paintings for the Mirror Room and Archive in a Studio off the Courtyard, Neue Galerie am Landesmuseum Joanneum, Graz 📖

1997
Galerie Rolf Ricke, Cologne
Galerie Bob van Orsouw, Zürich
Patricia Faure Gallery, Los Angeles

1998
David Reed Paintings: Motion Pictures, Museum of Contemporary Art, San Diego (touring) 📖
University,Ohio; P.S.1 Contemporary Art Center,New York (touring)
Vampire Archive/Research Project, Art Resources Transfer Inc., New York 📖

1999
Max Protetch Gallery, New York
Painting/Vampire Study Center:
Is Looking at an Abstract Painting Similar to a Vampire not Reflecting in a Mirror? Goldie Paley Gallery, Moore College of Art and Design, Philadelphia (touring)

2000
Galerie Rolf Ricke, Cologne
Galerie Bob van Orsouw, Zürich

Selected Group Exhibitions

1996
Extended Minimal, Max Protech Gallery, New York.
Nuevas Abstracciones, Museo Nacional Centro de Arte Reina Sofia, Madrid (touring)
Abstract Practice, Galerie Thaddaeus Ropac, Salzburg
Form als Ziel mündet immer in Formalismus, Galerie Rolf Ricke, Cologne
Embededded Metaphor, Independent Curators, Inc., New York
Reconditioned Abstraction, Forum for Contemporary Art, St. Louis, Missouri
Lydia Dona and New York Abstraction, Macdonald Stewart Art Centre, Guelph, Ontario
David Reed/ Philip Akkerman, Baumgartner Galleries, Washington DC

1997
Theories of the Decorative: Abstraction and Ornament in Contemporary Painting, Inverleith House, Royal Botanic Garden, Edinburgh (touring) 📖
Primarily Paint, Museum of Contemporary Art, San Diego, La Jolla, California
After the Fall: Aspects of Abstract Painting Since 1970, Snug Harbor Cultural Center, Staten Island, New York
Schilderijen: Reinoud Van Vaught, Fabian Marcaccio, David Reed, Jonathan Lasker, Gallerie Tanya Rumpff, Haarlem
Critiques Of Pure Abstraction, Independent Curators, Inc., New York 📖
Stepping Up, Andrew Mummery, London
Relations Between Contemporary Architecture and Painting, Künstlerhaus Palais Thurn und Taxis, Bregenz
Some Lust, Patricia Faure Gallery, Santa Monica

1998
The Erotic Sublime (Slave to the Rhythm), Galerie Thaddaeus Ropac, Salzburg
Pop Abstraction, Museum of American Art of the Pennsylvania Academy of the Fine Arts, Philadelphia
Utz: A Collected Exhibition, Weinberg, Inc. New York.
Interior Landscapes: An Exhibition from the Collection of Clifford Diver, Delaware Art Museum, Wilmington, Delaware
From Here to Eternity: Painting in 1998, Max Protetch Gallery, New York

1999
Moving Images: Reflexionen in der Kunst. Galerie für Zeitgenössische Kunst,Leipzig/ Siemens, Kulturprogramm, Leipzig 📖
Notorious: Alfred Hitchcock and Contemporary Art, Museum of Modern Art, Oxford 📖
Abstrakt: Eine Definition Abstrakter Kunst an der Schwelle des Neuen Milleniums, Max Gandolph-Bibliothek, University Salzburg, Salzburg 📖
special offer, Kassler Kunstverein, Kassel
Postmark: An Abstract Effect, SITE Santa Fe, Santa Fe
Collectors Collect Contemporary: 1990-1999, Institute of Contemporary Art, Boston

2000
Das Gedächtnis der Malerei, Aargauer Kunsthaus, Aarau 📖
Body of Painting - Günther Umberg: Mit Bildern aus Kölner Sammlungen, Museum Ludwig, Cologne
How You Look at It: Photographs in the 20th Century, Sprengel Museum, Hanover
Eva Knutz & David Reed: Conversation Exhibition, Art Resources Transfer, New York
Passe Compose / Futur Anterieur, Musée, d'Art Roger-Quillot and Fonds Regional d'Art Contemporain d'Auvergne, Clermont-Ferrand and Auvergne
Six Abstract Artists at the Millennium: Richard Anuskiewicz, Thom Cooney Crawford, Lydia Dona, Fabian Marcaccio, David Reed, Dorothea Rockburne, Dorsky Gallery, New York

Fiona Rae

1983-84, Croydon College of Art, Croydon
1984-87, Goldsmiths College of Art, London

Solo Exhibitions
📖 denotes accompanying catalogue

1990
Third Eye Centre, Glasgow 📖
Pierre Bernard Gallery, Nice 📖

1991
Waddington Galleries, London 📖

1992
Kunsthalle Basel, Basel 📖

1993-94
Institute of Contemporary Arts, London 📖

1994
John Good Gallery, New York 📖
Galerie Nathalie Obadia, Paris

1995
Waddington Galleries, London 📖

1996
Contemporary Fine Arts, Berlin 📖

1997
Saatchi Gallery, London (with Gary Hume) 📖
The British School at Rome
Luhring Augustine, New York

1999
Kohji Ogura Gallery, Nagoya 📖
Luhring Augustine, New York

2000
Buchmann Galerie, Cologne
Galerie Nathalie Obadia, Paris
fig-1, London 📖

Selected Group Exhibitions

1988
Freeze, Surrey Docks, London 📖

1989
Promises, promises, Serpentine Gallery, London (touring) 📖

1990
British Art Show, Hayward Gallery, London (touring) 📖
Aperto, Venice Biennale, Venice 📖

1991
Who Framed Modern Art or the Quantitative Life of Roger Rabbit, Sidney Janis Gallery, New York 📖
A View of London, Salzburger Kunstverein, Salzburg 📖
Turner Prize, Tate Gallery, London 📖

1992
Play between Fear and Desire, Germans van Eck Gallery, New York
Witte de With, Centre for Contemporary Art, Rotterdam

1993
Moving into View: Recent British Painting, Arts Council Collection Exhibition, Royal Festival Hall, London (touring) 📖

1994
Unbound: Possibilities in Painting, Hayward Gallery, London 📖
Here and Now, Serpentine Gallery, London

1995
Repicturing Abstraction, Marsh Art Gallery, University of Virginia, Richmond 📖
From Here, Waddington Galleries; Karsten Schubert, London 📖
Des limites du tableau: Les possibles de la peinture, Musée Départemental de Rochechouart, Chateau de Rochechouart, Haute-Vienne

1996
Nuevas Abstracciones, Palacio de Velazquez, Museo Nacional Centro de Arte Reina Sofia, Madrid (touring) 📖

About Vision: New British Painting in the 1990s, Museum of Modern Art, Oxford (touring) 📖

1997
Treasure Island, Calouste Gulbenkian Foundation, Lisbon 📖
Sensation: Young British Artists from the Saatchi Collection, Royal Academy of Arts, London (touring) 📖

1998
Ace!, Axis, http://www.lmu.ac.uk/ces/axis
UK Maximum Diversity, Benger Fabrik, Bregenz, Austria, organized by Galerie Krinzinger, Vienna 📖

1999
Colour Me Blind!, Württembergischer Kunstverein, Stuttgart (touring) 📖

2000
Zeitgenossen/Contemporarians: Malerei/Paintings, Galerie Edition Kunsthandel, Essen
Europa: differenti prospettive nella pittura, Fondazione Michetti Francavilla al Mare, Italy 📖

Monique Prieto

1987, UCLA
1992, California Institute of the Arts
1994, California Institute of the Arts

Selected Solo Exhibitions

1994
ACME, Santa Monica, California

1995
ACME, Santa Monica, California

1996
Bravin Post Lee, New York
ACME, Santa Monica, California

1997
Virginia Commonwealth University,
Richmond, Virginia
ACME, Los Angeles

1998
Robert Prime, London
Pat Hearn Gallery, New York

1999
ACME, Los Angeles, California

2000
ACME, Los Angeles, California
Corvi-Mora, London

Selected Group Exhibitions

1994
Happy Show, Lockheed Gallery, Valencia,
California
Temporary, Thesis Show, MOCA-Temporary
Contemporary, Los Angeles

1996
Chalk, Factory Place Gallery, Los Angeles
Painting All-Over, Again, Ayuntamiento de
Zaragoza, Spain
Trans/Inter/Post: Hybrid Spaces, Art Gallery,
University of California at Irvine
Stream of Consciousness, University Art
Museum, University of California at Santa
Barbara

The New Narrative Abstraction, The Art
Gallery at Brooklyn College; La Guardia Hall,
New York

1997
L.A. Current: New View, UCLA, Los Angeles,
California
1997 Biennial, Orange County Museum of
Art, California

1998
Painting: Now and Forever Part 1, Pat Hearn
Gallery; Matthew Marks Gallery,
New York
Abstract Painting, Once Removed,
Contemporary Arts Museum, Houston,
Texas ▯
Color Fields, Luckman Fine Arts Gallery,
California State University, Los Angeles

1999
Local Color, Harris Art Gallery, University of
La Verne, La Verne
Etcetera, Spacex Gallery, Exeter
Color Volume, Kunsthallen Brandts
Klædefabrik, Odense
Malerei, INIT Kunst-Halle Berlin
Colour Me Blind!, Württembergischer
Kunstverein, Stuttgart (touring) ▯
Facts & Fictions II: Los Angeles, In Arco,
Torino

2000
The Figure in the Landscape, Lehmann
Maupin Gallery, New York
Pict, Walter Phillips Gallery, Banff Centre,
Alberta
Ambient Fiction, Pat Hearn Gallery, New
York

2001
*Complementary Studies: Recent Abstract
Painting*, Harris Museum and Art Gallery,
Preston

Sarah Morris

1995
Ouro de Artista, Galeria Casa Triângulo, São Paulo
Impressões Itinerantes, Palácio das Artes, Belo Horizonte
Excesso, Paço das Artes, São Paulo
Duarte, Museo Alejandro Otero, Caracas
Brasil Contemporâneo, Casa da America Latina, Madrid
Pequenas Mãos, Paço Imperial, Rio de Janeiro; Centro Cultural Alumni, São Paulo
Coleção João Sattamini, Museu de Arte Contemporânea de Niterói, Niterói

1996
Theories of the Decorative, Inverleith House, Edinburgh ▯
Desde el Cuerpo: Alegorias de lo Feminino, Museo de Bellas Artes, Caracas

1997
XXIV Bienal Internacional de São Paulo, São Paulo
Biennale of Sydney, Sydney
Painting Language, LA Louver, Los Angeles
Abstract Painting, Once Removed, Contemporary Arts Museum, Houston ▯
Um Olhar Brasileiro, Coleção Gilberto Chateaubriand, Haus der Kulturen der Welt, Berlin

1999
Objetos Anos 90, Instituto Cultural Itaú, São Paulo
Tansvanguarda Latino Americana, Culturges, Lisbon

2000
Projects, Museum of Modern Art, New York
A Imagem do Som de Chico Buarque, Museu Paço Imperial, Rio de Janeiro
XII Mostra da Gravura da Cidade de Curitiba, Curitiba
Fricciones, Museo Nacional Centro de Arte Reina Sofia, Madrid

1989, Brown University, Providence, Rhode Island
1990, Whitney Independent Study Programme, New York
2000, American Academy, Philip Morris Award

Solo Exhibitions
▯ denotes accompanying catalogue

1996
Sugar, Gallery Philippe Rizzo, Paris ▯
Drawings, Anton Kern, New York
One False Move, White Cube, London

1998
Sarah Morris, Galerie Max Hetzler, Berlin
Sarah Morris, Le Consortium, Centre d'Art Contemporain, Dijon ▯

1999
Sarah Morris, Museum of Modern Art, Oxford ▯
Sarah Morris, Friedrich Petzel Gallery, New York

2000
Sarah Morris, Rumjungle, White Cube, London
Sarah Morris, Kunsthalle, Zürich ▯
Midtown and AM/PM, Philadelphia Museum of Art, Philadelphia

Selected Group Exhibitions

1990
Series, Postmasters Gallery, New York
Open Studio, Whitney Independent Study Program, New York

1991
Group Show, P.P.O.W., New York
Group Show, Postmasters Gallery, New York

1992
Curio Shop, Thread Waxing Space, New York

1993
Lucky Kunst, Silver Place, London
Home Alone, 211 East 10, New York
Evidently 1993, Dooley Le Capellaine Gallery, New York
I am the Annuniciator, Thread Waxing Space, New York

1994
Summer Group Show, Nicole Klagsbrun, New York
Please Dont Hurt Me, Galerie Snoie, Rotterdam; Cabinet Gallery, London

1995
Group Show, Nicole Klagsbrun, New York
B-Movie, San Francisco Art Fair, Phoenix Hotel, San Francisco
More Than Real, Gallery 400, School of Architecture, Chicago

1996
Found Footage, Klemens Gasser & Tanja Grunert, Cologne
Pop Planet, Theoretical Events, Naples

1997
Narrative Urge, Uppsala Konstmuseum, Sweden
Hospital, Galerie Max Hetzler, Berlin ▯
Dramatically Different, Centre National d'Art Contemporain de Grenoble, Grenoble ▯

1998
Young Americans Part 2, Saatchi Gallery, London ▯
Weather Everything, Galerie für Zeitgenössische Kunst, Leipzig ▯

1999
Fotografische Recherchen in der Stadt, Österreichische Galerie Belvedere, Vienna ▯
Frieze, Institute of Contemporary Art, Boston ▯
Post-hypnotic, University Galleries of Illinois State University, Illinois (touring) ▯

Beatriz Milhazes

1999
Painting Language, LA Louver, Los Angeles, California
Macro-Micro, Jack S Blanton Museum of Art, Austin, Texas
Abstrakt : Eine Definition Abstrakter Kunst an der Schwelle des Milleniums, Galerie Thaddaeus Ropac, Salzburg

2000
Snapshot, Contemporary Museum, Baltimore
Unlimited Space, Les Filles du Calvaire, Paris
Flux and Transparencies, Les Filles du Calvaire, Paris
Six Abstract Artists at the Millennium: Richard Anuskiewicz, Thom Cooney Crawford, Lydia Dona, Fabian Marcaccio, David Reed, Dorothea Rockburne, Dorsky Gallery, New York

1981-82, School of Visual Arts, Parque Lage, Brazil
1978-81, Curso de Comunicacao Social, Facha, Brazil

Selected Solo Exhibitions
Ⓤ denotes accompanying catalogue

1989
Pasárgada Arte Contemporânea, Recife

1990
Galeria Saramenha, Rio de Janeiro

1991
Subdistrito Comercial de Arte, São Paulo

1993
Galeria Camargo Vilaça, São Paulo Ⓤ
Sala Alternativa, Caracas

1994
Galeria Ana Maria Niemayer, Rio de Janeiro
Galeria Ramis F. Barquet, Monterrey Ⓤ
Paço Imperial, Rio de Janeiro

1995
Projeto Finep, Paço Imperial, Rio de Janeiro
Dorothy Goldeen Gallery, Los Angeles

1996
Galeria Camargo Vilaça, São Paulo
Centro de Artes Calouste Gulbenkian, Rio de Janeiro
Edward Thorp Gallery, New York

1997
Galerie Barbara Farber, Amsterdam
Galeria Elba Benitez, Madrid
Edward Thorp Gallery, New York

1998
Galerie Natalie Obadia, Paris
Gravuras, Paço Imperial, Rio de Janeiro
Pinturas, Galeria Ana Maria Niemeyer, Rio de Janeiro

1999
Stephen Friedman Gallery, London

2000
Galeria Camargo Vilaça, São Paulo
Edward Thorp Gallery, New York

2001
Ikon Gallery, Birmingham
Galeria Pedro Cera, Lisbon
Galerie Natalie Obadia, Paris
Galeria Elba Benitez, Madrid

Selected Group Exhibitions

1990
BR/80 A Pintura dos Anos 80, Casa França-Brasil, Rio de Janeiro Ⓤ

1991
Eco-Arte, Museu de Arte Moderna, Rio de Janeiro

1993
Encuentro Interamericano de Artes Plasticas-Dialogo sobre Siete Puntos, Museo de Guadalajara, Guadalajara
Gravuras, Espaço Namour, São Paulo
Brasil Contemporâneo, Casa da Imagem, Curitiba
Coleção Gilberto Chateaubriand, Museu de Arte Moderna, Rio de Janeiro
A Caminho do Museu, Centro Cultural São Paulo, São Paulo
Encontros e Tendências, Museu de Arte Contemporânea da Universidade de São Paulo, São Paulo

1994
Carnegie International, The Carnegie Museum of Art, Pittsburgh Ⓤ
Anos 80: o palco da diversidade, Museu de Arte Moderna, Rio de Janeiro, Ⓤ
Transatlântica - The America-Europa Non Representativa, Museo Alejandro Otero, Caracas
Panorama da Atual Arte Brasileira, Museu de Arte Moderna, São Paulo Ⓤ

Fabian Marcaccio

University of Philosophy, Rosario, Santa Fe, Argentina

Solo Exhibitions
📖 denotes accompanying catalogue

1992
John Post Lee Gallery, New York
Inter Painting, Jason Rubell Gallery, Palm Beach, Florida* 📖

1993
The Altered Genetics of Painting, John Post Lee Gallery, New York
Mutual Betrayal, Barbara Farber Gallery, Amsterdam
Unpaintables, Anders Tornberg Gallery, Lund

1994
On Unpaintables, Thaddeus Ropac Gallery, Paris
New Paint Management, Galerie Rolf Ricke, Cologne

1995
Paint-Zone, Bravin Post Lee Gallery, New York
Paint-Zone LA, LA Louver Gallery, Los Angeles
Use of Evidence, Contemporary Art Museum, Florida

1996
Conjectural Amendments, Bravin Post Lee Gallery, New York; Expoarte; Guadalajara

1997
Paintants, Baumgartener Gallery, Washington DC
Paintants #2, Schmidt Contemporary Art, St Louis, Missouri

1998
Fabian Marcaccio - Jessica Stockholder, Sammlung Goetz, Munich
Fabian Marcaccio - Jessica Stockholder, With-ject Spain, Joan Prats Gallery, Barcelona; Salvador Dia Gallery, Madrid
Paintants #3, Mario Diacono Gallery, Boston

Paintants Compounds, Galerie Rolf Ricke, Cologne
Con-jecto Argentina, Galeria Ruth Benzacar, Buenos Aires
Orlando Museum of Modern Art, Orlando, Florida

Selected Group Exhibitions

1992
Theoretically Yours, The Museum of Aosta, Aosta 📖

1993
Tool Box, Studio la Città, Verona 📖
Teddy and Other Stories, Claudio Bottello Arte, Turin; Galleria in Arco, Turin 📖
The Post-Dialectical Index, Romley Gallery, New York 📖
Irony & Ecstasy, Salama-Caro Gallery, London 📖

1994
De-Pop, Connecticut College, Connecticut
Painting Language, LA Louver, Los Angeles
Fractured Seduction, Artifact Gallery, Tel Aviv 📖
Conditional Painting, Galerie Nächt St. Stephan, Vienna
Possible Things, Bardamu Gallery, New York
Meta-Material, Plasma, Sagaponack, New York

1995
The Corcoran Biennial Exhibition, The Corcoran Museum of Art, Washington DC
Art at the edge: Tampering Artists and Abstraction, The High Museum, Atlanta, Georgia 📖
Malerei, Busche Gallery, Berlin (with Callum Innes)
Transatlantica, Museo Alejandro Otero, Caracas
The Adventure of Painting, Kunstverein, Düsseldorf; Kunstverein, Stuttgart
Mesotica, Museo de Arte e Diseno Contemporaneo, San Jose, Costa Rica
Pittura Immedia, Neue Galerie am Landesmuseum Joanneum, Graz

Architecture of The Mind, Galerie Barbara Farber, Amsterdam 📖
New York Abstract, Contemporary Arts Center, New Orleans

1996
Camargo Vilaça BIS, Studio Segall, São Paulo
Transformal, The Wiener Secession, Vienna 📖
Painting in an Expanding Field, The Ursan Gallery, Bennington College, Vermont
Without Frontiers, Museo Alejandro Otero, Caracas

1997
New York Abstraction, Macdonald Stewart Art Centre, Ontario
Ca-Ca Poo-Poo, Kölnischer Kunstverein, Cologne
Grito, Museum Nacional de Bellas Artes, Rio de Janeiro
Premillennial Tension, Marella Arte Contemporanea, Sarnico (touring)
New York, Galleri F 15, Jeloy
In-Form, Bravin Post Lee Gallery, New York
De Visiones Y de Ritmos, Centro cultural Parque Espana, Rosario
Relations between Contemporary Architecture and Painting, Künstlerhaus Palais Thurn und Taxis, Bregenz
Vertical Painting, PS1 Contemporary Art Center, New York

1998
Sick of Photography: A Painting Show, Santa Barbara Museum, California
The Forty-Fifth Biennial, Corcoran Gallery of Art, Washington DC
Abstract Painting Once Removed, Contemporary Arts Museum, Houston, Texas
Spectacular Optical, Thread Waxing Space, New York

artists' biographies and bibliographies

Inka Essenhigh

Dresden 📖
Mysliwska, Künstlerhaus Bethanien, Berlin
"Utopische Bürger"?, workweb.art, Cologne

2001
close up, Kunstverein Hannover, Hanover
painting at the edge of the world, Walker Art
Center, Minneapolis 📖
comfort: reclaiming place in a virtual world,
Cleveland Center for Contemporary Art,
Cleveland 📖
Brown Field, Rob Tufnell, Glasgow

1988-1992, Columbus College of Art &
Design, Columbus, Ohio
1992-1994, School of Visual Arts, New York

Solo Exhibitions
📖 denotes accompanying catalogue

1997
Wallpaper Paintings, La Mama La Galleria,
New York

1998
Recent Paintings, Stefan Stux Gallery,
New York

1999 - 2000
New Paintings, Deitch Projects, New York
*American Landscapes: Recent Paintings by
Inka Essenhigh*, New Room of
Contemporary Art, Albright Knox Art Gallery,
Buffalo 📖

2000
Victoria Miro Gallery, London
Mary Boone Gallery, New York

Selected Group Exhibitions

1993
*Young Ukrainian-American Painters Group
Show*, Ukrainian Museum, New York
*Work-Play; Picture Thinking and the
Analogical Imagination*, Visual Arts Gallery,
New York

1996
Set Off: Inaugural Group Show, View Room
Exhibitions, New York
*Underexposed; Nine Young American
Painters*, André Zarre Gallery, New York
Anatomy Intellect, Stefanelli Exhibition
Space, New York

1997
Sex/Industry, Stefan Stux Gallery, New York
The Art Exchange Fair, with Stefan Stux
Gallery, New York
Girls! Girls! Girls!, Tricia Collins Grand Salon,
New York

1998
The New Surrealism, Pamela Auchincloss
Project Space, New York
Wild, Exit Art/The First World, New York
Pop Surrealism, The Aldrich Museum of
Contemporary Art, Ridgefield, Connecticut 📖
Summer Review, 98, Stefan Stux Gallery,
New York
*Celebrating Diversity: Contemporary Women
Painters*, Hillwood Art Museum, Long Island
University, New York
ANATOMY/INTELLECT, Stefanelli Exhibition
Space, New York
Blade Runner, Caren Golden Fine Art, New
York

1999
Pleasure Dome, Jessica Fredericks Gallery,
New York
The Armory Show, Stefan Stux Gallery, New
York

2000
*Greater New York: New Art in New York
Now*, PS1 Contemporary Art Center, New
York
Deitch/Steinberg New Editions, Deitch
Projects, New York
Emotional Rescue, Center for Contemporary
Art, Seattle
To Infinity and Beyond, Brooke Alexander,
New York

Franz Ackermann

1984-88, Akademie der Bildenden Künste, Munich
1989-91, Hochschule für Bildende Kunst, Hamburg
DAAD, Hong Kong

Solo Exhibitions
📖 denotes accompanying catalogue

1994
Ackermann's Wörterbuch der Tätigkeiten, Buchpublikation
Dialo(o)g, Belgisches Haus, Cologne
condominium, Neugerriemschneider, Berlin

1995
Thomas Solomon's Garage, Los Angeles
Gavin Brown's enterprise, New York

1996
Das weiche Zimmer, Hanover
Neugerriemschneider, Berlin

1997
unexpected, Gavin Brown's enterprise, New York
unerwartet, Kunstpreis der Stadt, Nordhorn
Mai 36 Galerie, Zürich
Portikus, Frankfurt
Gió Marconi, Milan

1998
White Cube, London
Neugerriemschneider, Berlin
Das Haus am Strand und wie man dorthin kommt, Meyer Riegger Galerie, Karlsruhe
Pacific, White Cube, London
Songline, Neuer Aachener Kunstverein, Aachen

1999
OFF, Kasseler Kunstverein, Kassel
Trawler, Mai 36 Galerie, Zürich

2000
Castello di Rivoli, Torino
Galeria Camargo Vilaça, São Paulo
welt 1... and no one else wanted to play, Meyer Riegger Galerie, Karlsruhe
reisterrassen von basel, Wandmalerei,
Rückwand der Kunsthalle, Basel

2001
Gavin Brown's enterprise, New York
Neugerriemschneider, Berlin
Gió Marconi, Milan
Tomio Koyama, Tokyo

Group Exhibitions

1996
Wunderbar, Kunstverein Hamburg, Hamburg 📖
Faustrecht der Freiheit, Sammlung Volkmann, Berlin; Kunstsammlung Gera/Neues Museum Weserburg, Bremen

1997
Urban Living, Galerie Fons Welters, Amsterdam
Kunst...Arbeit, Südwest LB, Stuttgart 📖
Heaven, PS1 Contemporary Art Centre, New York
Kunstpreis der Böttgerstraße in Bremen, Bonner Kunstverein, Bonn 📖
Time Out, Kunsthalle Nürnberg, Nürnberg 📖
Atlas Mapping, Offenes Kulturhaus, Linz 📖
Topping out, Städtische Galerie, Nordhorn
Gió Marconi, Milan
Imbiss, Künstlerhaus, Stuttgart

1998
Franz Ackermann und Jonathan Meese, Sammlung Volkmann, Berlin
Ferien, Utopie, Alltag, Künstlerwerkstatt Lothringer Straße, Munich
Osygus, Produzentengalerie Hamburg, Hamburg
Painting: Now and Forever, Part I, Pat Hearn Gallery; Matthew Marks Gallery, New York
Hanging, Galeria Camargo Vilaça, São Paolo (touring) 📖
sehen sehen, Loop - Raum für Aktuelle Kunst, Berlin
Atlas Mapping, Kunsthaus, Bregenz 📖

1999
German Open, Kunstmuseum Wolfsburg, Wolfsburg 📖
Carnegie International 1999/2000, Carnegie Museum of Art, Pittsburgh 📖
Mirror's Edge, BildMuseet, Umea (touring) 📖
Officina Europa, Galleria d'Arte Moderna, Bologna 📖
Malerei, INIT Kunst-Halle, Berlin
Drawn from Artists' Collections, The Drawing Center, New York 📖
amAzonas Künstlerbücher, Villa Minimo, Hanover
Zoom, Sammlung Landesbank Baden-Württemberg, Stuttgart (touring) 📖
Go Away: Artists and Travel, Royal College of Art, London 📖
Dream City, Kunstverein München, Munich 📖
Otto&, Otto, Copenhagen
<Anderswo 1>, Kunstraum, Kreuzlingen
Frieze, Institute of Contemporary Art, Boston 📖

2000
More works about buildings and food, Fundição de Oeiras, Hangar K7, Oeiras
Glee: Painting Now, The Aldrich Museum of Contemporary Art, Ridgefield; Palm Beach Institute of Contemporary Art, Palm Beach 📖
home ist where the heArt is, Museum van Loon, Amsterdam
DAAD: weltwärts, Kunstmuseum Bonn, Bonn
Salon, Delfina Project Space, London
Millefleurs, Picture Show, Berlin
Malkunst, Fondazione Mudima, Milan 📖
Kunst und Mode, Picture Show, Berlin,
Re-public, Grazer Kunstverein, Graz (with Rirkrit Tiravanija)
Loneliness in the City, Migros Museum, Zürich (with Rirkrit Tiravanija)
LKW Lebenskunstwerke, Kunst in der Stadt 4, Kunsthaus Bregenz, Bregenz 📖
Bleibe, Akademie der Künste, Berlin
[re:songlines], Halle für Kunst, Lüneburg
Close up, Kunstverein Freiburg, Freiburg; Kunsthalle Baselland, Basel 📖
hausschau - das haus in der kunst, Deichtorhallen Hamburg, Hamburg 📖
CITY-INDEX, Festspielhaus Hellerau,

Fiona Rae

David Reed

Over and Over
2000
Acrylic on canvas
2133 x 1828
Dallas Price
p.39 ☒

Angel
2000
Oil and acrylic on canvas
2460 x 2035
Courtesy of the artist
p.45

Dark Star
2000
Oil, acrylic and glitter on canvas
2460 x 2035
Courtesy of the artist
p.43

Lovesexy
2000
Oil, acrylic and glitter on canvas
2460 x 2035
Courtesy of the artist
p.42

Bewitched
2001
Oil, acrylic and glitter on canvas
2460 x 2035
Courtesy of the artist
p.44

Rodeo
2001
Oil, acrylic and glitter on canvas
2460 x 2035
Courtesy of the artist

Sweet Dreams
2001
Oil, acrylic and glitter on canvas
2460 x 2035
Courtesy of the artist

#328
1990-93
Oil and alkyd on linen
730 x 1420
Private Collection,
Cologne, courtesy of
Galerie Rolf Ricke,
Cologne

Judy's Bedroom
1993-99
Mixed Media
Variable dimensions
Galerie Rolf Ricke,
Cologne
p.46

#452
1994-2000
Oil and alkyd on linen
685 x 3657
Private Collection,
Amsterdam
p.47

#454
1994-2000
Oil and alkyd on linen
812 x 4267
Private Collection, Oslo

#467
1994-2000
Oil and alkyd on linen
914 x 3657
Private Collection,
Switzerland. Courtesy of
Galerie Bob van Orsouw,
Zurich
p.49

#457
1996-2000
Oil and alkyd on linen
914 x 3657
Private Collection
p.48 ☒

#461
1999-2000
Oil and alkyd on linen
711 x 3657
Collection of Sydney and
Walda Besthoff.
Courtesy of Max
Protetch Gallery, New
York
p.46

Sarah Morris

A Seda
2000
Acrylic on canvas
2000 x 1888
Paula Lavigne and
Caetano Veloso
p.32

*Midtown 1211
(Rockefeller Plaza)*
1998
Gloss household paint
on canvas
2134 x 2134
Collection of MTV
Networks, New York,
courtesy Thea Westreich
Art Advisory Services,
New York
p.35

AM/PM
1999
16mm DVD. Running
time 12 mins. 36 secs.
Courtesy of Jay
Jopling/White Cube,
London

Midtown - Condé Nast
2001
Gloss household paint
on canvas
2140 x 2140
Courtesy of Jay
Jopling/White Cube,
London

*Midtown - Crowne Plaza
Hotel*
1999
Gloss household paint
on canvas
2134 x 2134
Rosa and Carlos de la
Cruz Collection
p.34 ☒

The Mirage [Las Vegas]
1999
Gloss household paint
on canvas
2140 x 2140
Private Collection
p.37

*Neon - Nitrogrill [Las
Vegas]*
2000
Gloss household paint
on canvas
2134 x 2134
Courtesy of William A.
Palmer

*Rio (with Palms) [Las
Vegas]*
2000
Gloss household paint
on canvas
2140 x 2140
Courtesy of Jay
Jopling/White Cube,
London
p.36

Monique Prieto

Cornered
1998
Acrylic on canvas
1828 x 2133
American Express
Financial Advisors

Revenge
1998
Acrylic on canvas
1820 x 1516
Private Collection,
London

Stir
1999
Acrylic on canvas
1828 x 2438
Stephanie and Dewey
Nicks
p.40

Moonlighting
2000
Acrylic on canvas
1525 x 1525
Private Collection,
London
p.38

Never Again
2000
Acrylic on canvas
1879 x 2133
Phyllis and John
Kleinberg
p.41

On The Other Side
1997
Acrylic on canvas
2440 x 1820
Dallas Price

list of work

Inka Essenhigh

Untitled Ruins II
2001
22 Framed photographs
273 x 368
Courtesy of Gavin
Brown's enterprise,
New York

White Crossing I
2001
Wall painting with wood
Variable dimensions
Courtesy of Gavin
Brown's enterprise,
New York, and
Neugerriemschneider,
Berlin
p.21

*White Crossing II
(the tunnel)*
2001
Wall painting with wood
Variable dimensions
Courtesy of Gavin
Brown's enterprise,
New York, and
Neugerriemschneider,
Berlin

Blue Moon
1999
Oil on canvas
1828 x 1828
Collection of Edward
Boyer, New York,
courtesy of Mary Boone
Gallery, New York

Born Again
1999
Oil on canvas
2290 x 1990
Courtesy of Victoria Miro
Gallery, London
p.23

Cheerleaders and Sky
1999
Oil and enamel on
canvas
1981 x 2286
Courtesy of Andrew
Schorr
p.22

Goody
1999
Oil and enamel on
canvas
2286 x 1930
Ninah and Michael
Lynne, courtesy of Mary
Boone Gallery, New York
p.25

White Rain
2001
Oil and enamel on
canvas
1830 x 1880
Courtesy of Victoria Miro
Gallery, London
p.24 ⊠

Fabian Marcaccio

*Time Paintant: Image
Addiction Paintant*
1999
Encad GO inks on
canvas with silicon gel,
oil, acrylic and cast
polyoptics
2641 x variable width x
609
Courtesy of Gorney
Bravin + Lee, New York

Paintant Series
2000
Mixed media installation
at Württembergischer
Kunstverein, Stuttgart
Variable dimensions
Courtesy of Gorney
Bravin + Lee, New York
p.26-29 ⊠

Paintant Stories
2000
Mixed media installation
at Württembergischer
Kunstverein, Stuttgart
Variable dimensions
Courtesy of Gorney
Bravin + Lee, New York
p.26 ⊠

Beatriz Milhazes

A Praia
1997
Acrylic metallic paint and
metal leaf on canvas
2591 x 860
Purchase, Gift of
Professor and Mrs Zevi
Scharfstein, by
exchange, 1998. The
Metropolitan Museum of
Art, New York

As Quatro Estações
1997
Acrylic on canvas
2575 x 2845
Collection of the Bohen
Foundation, New York
p.33

O Pensamento Indiano
1997-98
Acrylic on canvas
1900 x 1600
Berardo Collection,
Sintra Museum of
Modern Art

Gavião e Passarinho
1998
Acrylic on canvas
2500 x 3500
Rosa and Carlos de la
Cruz Collection
p.30

Minhas Crianças
1999
Acrylic on canvas
1780 x 1770
Collection of Marta and
Rubens Schahin, São
Paulo
p.31

Franz Ackermann

747 Delivering a piece of my hometown (maybe they won't let it in)
2001
Mixed media on paper
228 x 300
Private Collection, courtesy of Gavin Brown's enterprise, New York

Abschied auf See
2000
Oil on canvas
2700 x 5400
Courtesy of Gavin Brown's enterprise, New York, and Neugerriemschneider, Berlin
p.20 ☒

All the Countries of the World
2001
Mixed media on paper
690 x 1000
Private Collection, New York, courtesy of Gavin Brown's enterprise, New York

The Cyclops in Hotel Botanico
2001
Mixed media on paper
205 x 282
Collection of James-Keith Brown and Eric Diefenbach, courtesy of Gavin Brown's enterprise, New York

Die Enteignung (The Kop in Blue)
2001
Mixed media on paper
720 x 620
Collection of Suzanne and Michael Hort, courtesy of Gavin Brown's enterprise, New York

The Drawing Corridor with The Sleeping Dragon
2001
Mixed media on paper
222 x 298
Private Collection, courtesy of Gavin Brown's enterprise, New York

Faceland
2001
Mixed media on paper
845 x 645
Collection of Martin and Rebecca Eisenberg, New York, courtesy of Gavin Brown's enterprise, New York

Head from Top
2001
Mixed media on paper
300 x 325
Collection of Ilene Kurtz-Kretzschmar and Ingo Kretzschmar, courtesy of Gavin Brown's enterprise, New York

Helicopter XVI
2001
Oil on canvas
2800 x 2900
Courtesy of Gavin Brown's enterprise, New York, and Neugerriemschneider, Berlin

Helicopter XVII
2001
Oil on canvas
2700 x 5400
Courtesy of Gavin Brown's enterprise, New York, and Neugerriemschneider, Berlin

Helicopter XVIII
2001
Oil on canvas
1900 x 2600
Courtesy of Gavin Brown's enterprise, New York, and Neugerriemschneider, Berlin

Main event, main location, main target
2001
Mixed media on paper
465 x 645
Private Collection, New York, courtesy of Gavin Brown's enterprise, New York

Mr Horror Comes to Town
2001
Mixed media on paper
260 x 215
Private Collection, courtesy of Gavin Brown's enterprise, New York

The Studio in the Desert
2001
Mixed media on paper
535 x 765
Courtesy of Gavin Brown's enterprise, New York
p.18

Two Friends
2001
Mixed media on paper
304 x 438
Private Collection, courtesy of Gavin Brown's enterprise, New York, and Neugerriemschneider, Berlin

Untitled (Pacific no.14: No one will ever obstruct your view)
2000
Mixed media on paper
250 x 330
Courtesy of Gavin Brown's enterprise, New York, and Neugerriemschneider, Berlin
p.19 ☒

All measurements are in millimetres.
☒ Not in exhibition.

our corporeal presence and our abilities to project ourselves into the space of painting, to revel in its sensuality. These are paintings about privacy, love and sex – that is to say they are about human intimacy. Reed refers to himself as a 'bedroom painter', this interior space is where his work is destined to hang. The bedroom is a place to make ourselves vulnerable, but also to shield us from the outside world. It allows relaxation and reverie, but also complex reflection on our experiences. This is paralleled in Reed's work that splits time up, compartmentalises it and then stretches it out into a flowing stream in which we are caught. This form of temporal acrobatics is what indexes his practice to that of filmmaking and photography. Reed's painted surfaces have a sheen to them reminiscent of the many illuminated screens upon which we watch and manipulate the visual world. But Reed's screens are paintings, and as such implicate the hand – we expect touch to be evoked.

Painting is a real thing in itself, not simply an abstraction and distillation of other experiences, although, of course, it contains these processes. Reed's work reminds us of how everything we encounter in the world is mediated, but the way in which we combine these mediations with our personal histories is what makes us unique. How we bring these different languages to bear upon experience is something that Reed's paintings make visible.

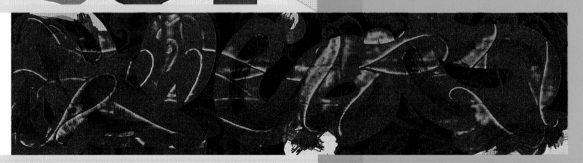

fashion parades a colour of the season and commercial interiors have increasingly assertive and recognisable tones. Similarly, Reed's paintings have an attention-grabbing colouristic violence to them: colour – like smell – lodges, locates and transports us. These paintings seem exotic and vivacious in their colour values. They make us yearn in some deep way for comfort and seduction. They create a sense of longing, but for what one cannot be certain. This is what makes us invest time in them, giving ourselves over to the memory of bodily experience whilst desiring new forms of experience in the future.

These works are not abstract; they are palpably present and real. They reaffirm

#457 1996-2000

#467 1994-2000

david reed

David Reed has been making abstract paintings since the early 1970s. He is fascinated by the way our perception of colour, light and time is influenced by films, television and new visual technologies. Baroque painting has also been highly influential on his work, particularly its synthesis of dynamic movement and theatrical effects that embody human experience and living pulsation. The largely horizontal orientation of his paintings makes them appear to be gradually unravelling like a form of scroll, embodying a languid sense of motion and time. Reed's works have sensual surfaces built-up in many layers of oil paint on gesso that are then sanded and varnished. They depict space through the juxtaposition of strong colour and he is particularly interested in the proliferation of new combinations of hues in daily life through the use of digital technologies.

These works have an erotic pull which is insistent because we cannot truly possess them, in the same way we can never truly possess a lover (they are separate from us, we have to be absent from them). This frustration sustains a relationship, keeps us coming back for more. The paintings that attract us most are hard to pull away from. We wonder how they came to be and they implicate us both viscerally and visually, as there is a dynamic play between these forces. Colour is the first thing that attracts us. It has become an ever more intense feature of our lives. Computer screens display millions of hues that vividly push their way into our consciousness,

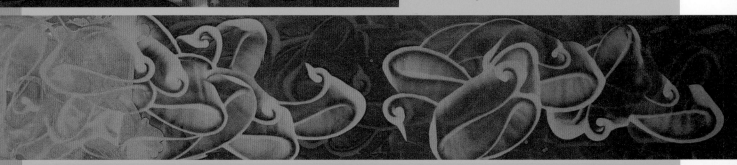

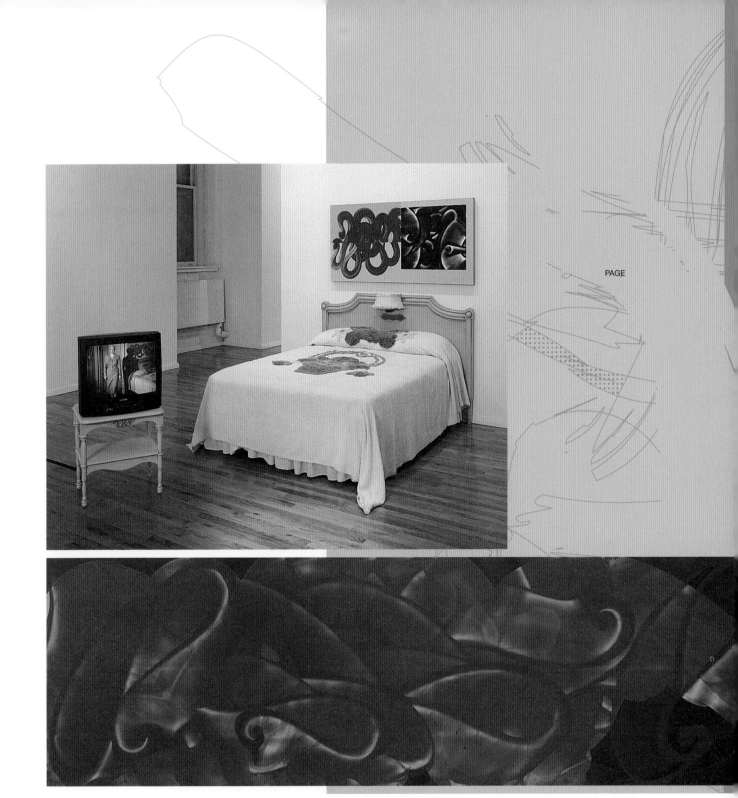

Judy's Bedroom
with #328 1993-99

#461 1999-2000

#452 1999-2000

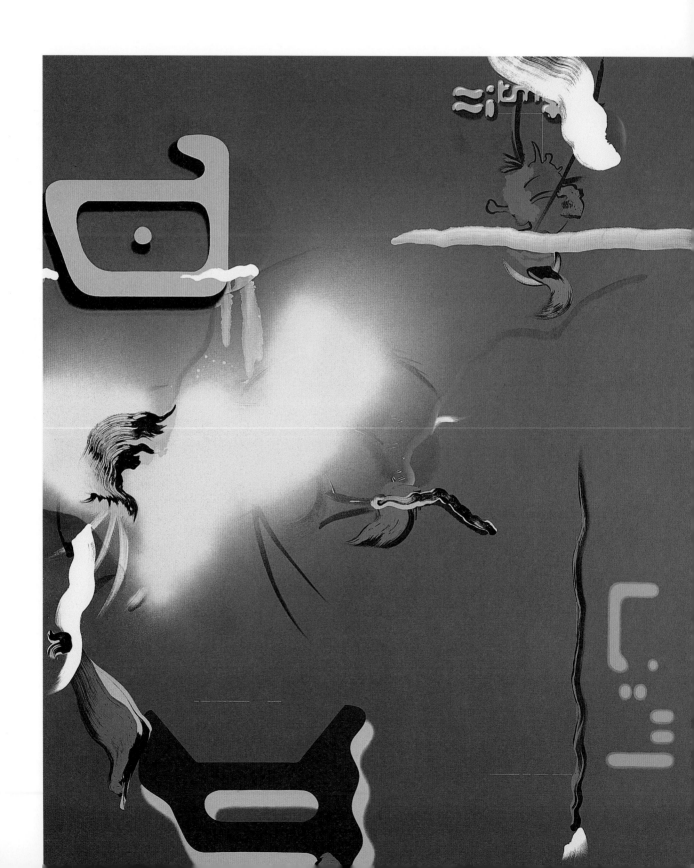

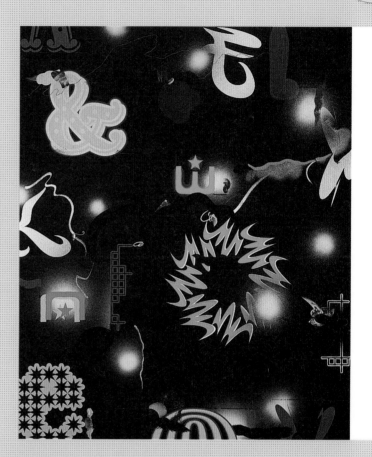

Rae's works operate as an index of her visual interests. Her latest paintings use a coloured ground in which various neon-style, typographic elements are embedded or seamlessly placed for our inspection. These are put into relationships with her familiar brushmark 'samples' that have a teasing presence that is less chaotically manic than her earlier works. The new paintings appear almost hermetically sealed; they are slick and funky, intelligent and sensuous. They have some of the browsing sensibility that shopping, television watching and using the internet has installed in us all. Rae's paintings also have a science fiction quality to them that recognises that the future is never as distant as it once seemed. This compression of time is due largely to the continuing vast increases in computing power that enables so much of what we can now achieve and imagine. Rae's work appears to be similarly driven and beguiled by the new spaces we are opening up for ourselves, serving to underline that there is never a moment of complete knowing: everything is always contingent.

Rae's visual thinking is finely honed but also makes use of free play and improvisation. These traits are at the heart of hybrid works that want to create new paradigms for vision in dialogue with the widest possible array of visual cultures. She uses glitter, spray guns and a palette that reflects the all consuming vagaries of designer fashion in a liberated way that side-steps the conventions of good taste and seriousness that plague certain forms of painting practice embodying the interests of a pre-digital generation. Although these are hardly fearless paintings – their anxiety is palpable – Rae takes many risks in her work. She cares to find things out and creates contingent solutions through the process of painting. Her works use a visual language familiar to those who browse music and clothes shops and who travel with their eyes open to the rapidly changing consumer landscape.

Bewitched 2001

Angel 2000

Born 1963, Hong Kong
Lives and works in London, UK

fiona rae

Fiona Rae's practice has inventively questioned, and played with the status of painting for over a decade. Rae indexes her work to a huge range of visual and cultural interests including electronic music, film, comics, cartoons, graphic design and the use of colour in designer fashion and interiors. Her hybridised painting language also references numerous art historical sources from Roy Lichtenstein and Philip Guston to Hieronymous Bosch and Jean Dubuffet, with myriad influences in between. Her work has consistently explored the possibilities of painting in relation to all her other concerns by restlessly and pragmatically reinventing itself. Rae doesn't appear to be worried by the status of what influences her if it can help move the paintings into new territories. Her practice utilises a democracy of taste that is essentially non-hierarchical but always convincingly engaged with what is current and 'out-there' in the world beyond the studio.

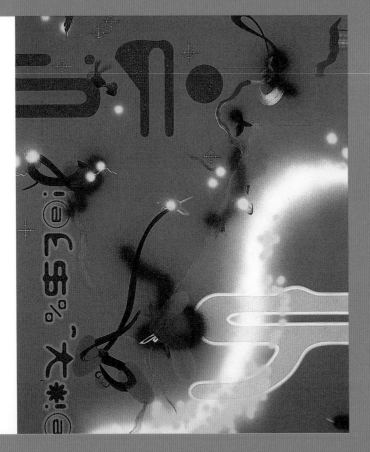

Rae has reinvigorated the language and dictionary of painting and, like a magpie, picks and chooses from art history, popular culture and graphic vernaculars at will. Her works bear witness to themselves; they are somehow self-conscious in the game playing and posing they use to see what they can get away with in reconfiguring new hybrid forms. They suck all that's new into their spaces, isolating the mark and the gesture as both highly contingent and open to possibility. Rae's paintings have always looked of the moment because of her receptiveness to the subtle changes in visual culture. However, they also embody the values of the tradition of painting. This is evinced in their craftsmanship and degree of, at times, intriguingly unlikely resolution whereby every element argues for its place. These are not merely 'fashion statements' but rather 'state of the art'. Her practice mutates, taking account of the accelerating pace of change.

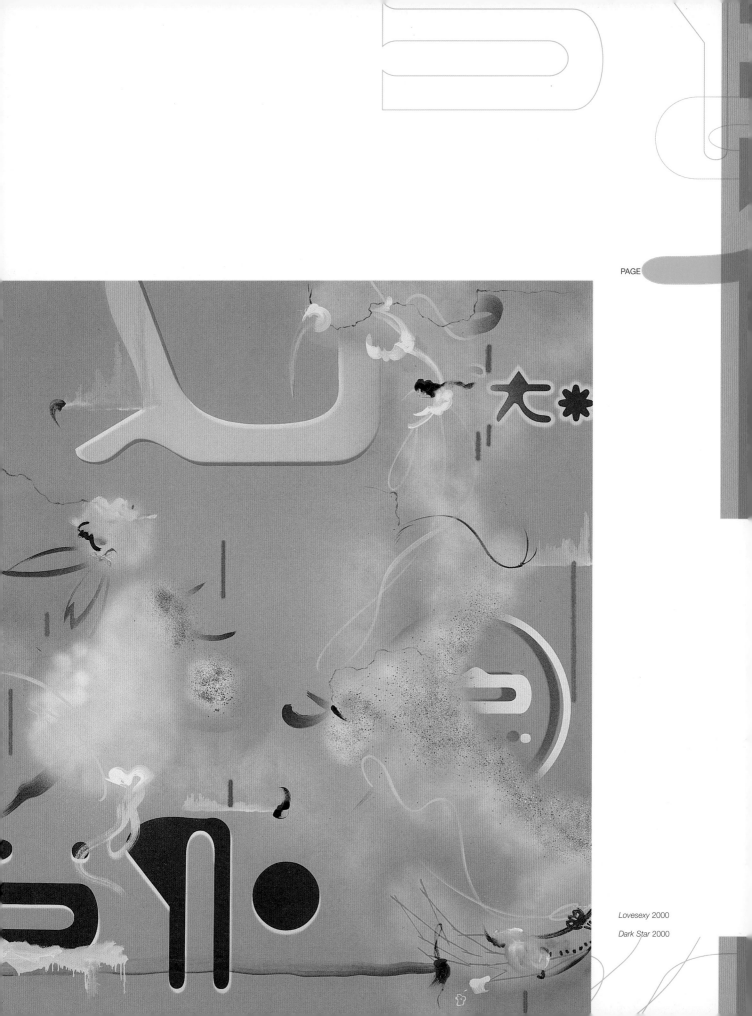

Lovesexy 2000

Dark Star 2000

that will reveal things that were hitherto occluded. It is here that Prieto's paintings inform us in a very humanistic way. They speak of the body and our intimate connections to one another, but they also have humour and an air of displaced melancholy.

Painting has always been a vital index to our humanity – to learn about what we have in common and how we might empathise with one another. Prieto evokes these qualities because her paintings are situational: what is going on? what has happened? and what is about to happen? There is no blanding out to a false sublimity in these works – we are always intriguingly aware of what is at stake in terms of the tradition of painting and its place as a subtly expressive art form. Her paintings have a captivating sense of mystery and irresolution to them through their implied narratives that implicate us in a game of interpretation, recognition and emotional empathy. These works make us realise that there is no such thing as disinterested formalism, because every formal decision about line quality, colour and shape has a resonance of meanings waiting to burst forth.

Stir 1999

Never Again 1999

PAGE

Born 1962, Los Angeles, USA
Lives and works in Los Angeles, USA

monique prieto

Monique Prieto's paintings have an audacious formal rigour and quirky visual humour all their own. These elegant and sophisticated abstracts don't shy away from being indexed to the physical world and one can't help but read narrative relationships into her anthropomorphic shapes. Prieto's colourful, cartoonish forms sit, sag, grope and lean against one another as if weighted and gravity bound. Her paint sits cleanly on top of raw, tautly stretched canvas, which features no drawing or underpainting as she draws the designs beforehand using a computer. These paintings extend, and play with, the tradition of Post-Painterly Abstraction to produce engagingly off-kilter works that side-step notions of the sublime in order to capture the tangible quality of sensate experience and intimate human relationships.

Prieto's works display the process by which abstraction absorbs emotive and narrative qualities. The painting becomes a fictional stage on which relationships are intriguingly played out. A stage seems to be the most apt evocation for these works because, like the unfurled paintings of Morris Louis, the viewer is encouraged to interact and project their own personal experience into the depicted scenarios. These paintings are not arrested at a formal level, although their formal qualities are obviously crucial – the particular hue and crisp application of paint fundamentally structures our reading of the work. However, in order to develop an aesthetic experience we have to seek out the 'truth-value' of each painting, to take it on board as a serious proposition

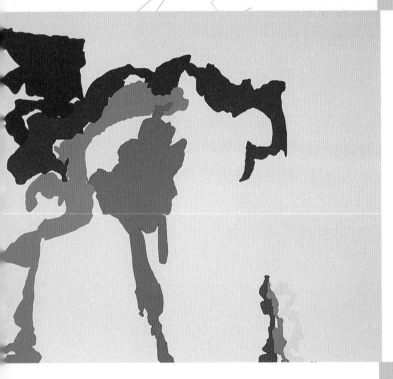

Moonlighting 2000

Over and Over 2000

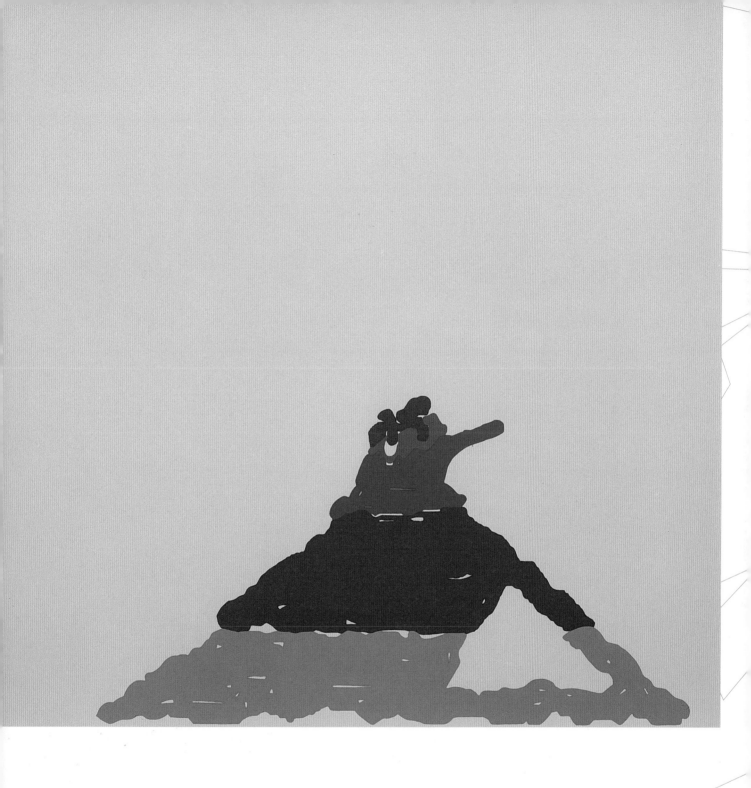

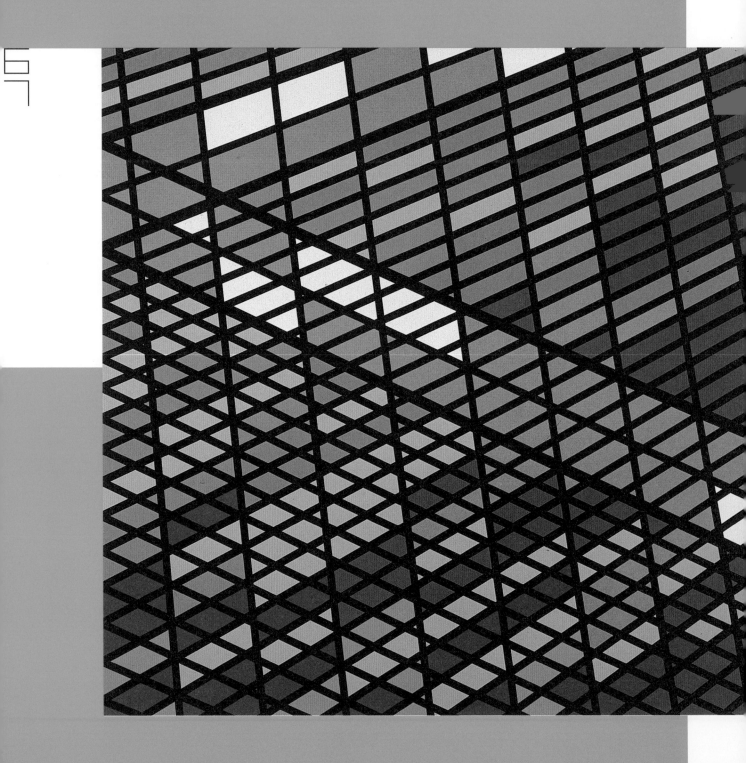

There are many improvisatory and decorative subtleties to these paintings in their closely controlled economy of energy. They celebrate the manmade and modern, partaking in the fascination of the flâneur who trawls the city as the archetypal consumer of visual surfeit and spectacle. The paintings and film play on the thrill of being overwhelmed and losing ourselves in the city. Morris' works engage with reflective architectural surfaces that offer no sense of an interior containing people with contradictory desires temporarily sublimated in order to perform a job for a corporation. Her work embraces the neon pulse of the city, which seduces and hypnotises, distracting us from the harsher realities of our urban lives.

These paintings make our looking active. The lines Morris uses are full of forces that both trip us up and lead us in. The coloured shapes that the intersections of these lines create flicker and punctuate the surface making their reception highly somatic. We search for a logic and an order in the visual organisation of these paintings. We also search for symbolic meaning: what is depicted here, what are the priorities of this work and how will we reconcile our own histories to what we are encountering?

We visually consume our world in ever increasing amounts because of the level of mediation it is put through and because of an increase in leisure time. We are in a constant state of agitation that even nature cannot allay, after-all it was largely the achievement of painting that enabled us to consume nature in a visual way that belied the realities of working the land. We aestheticise everything and assert our own human presence and libidinal energies in the fabric of the city. It is this economy to which Morris' paintings and films are closely indexed. They push modernist purity back into the realm of the body and messy, contradictory, desire, to achieve a more human position in relation to our environment. This position is not primarily romantic, but rather one that reveals our everyday situation of work habits, beliefs, commitment and desires as embodied and structured in the spectacular corporate architecture of our cities.

Rio (with palms) [Las Vegas]
2000

The Mirage [Las Vegas] 1999

Born 1967, New York, USA
Lives and works in London, UK, and New York, USA

sarah morris

Sarah Morris' paintings have a vertiginous and seductive quality to them through their regimented, foreshortened lines and juxtapositions of colour. She depicts the modernist structures of the city and the corporate slickness that pervades our urban lives, corralling us into a form of spectacular submission that attempts to leave us in no doubt as to the permanence and rightness of capitalism. Her paintings are formally reminiscent of Mondrian, or an artist such as Kenneth Martin, in their rigour and love of rhythm and movement. But there is no sense of moral purity to them; they are sexy and luscious, frivolous and engaging. These paintings make us yearn for something unidentifiable through their colours and physical implications of tumbling or falling into an impossible space. The gloss paint surface is thoroughly controlled, mirroring the faceless façades of the buildings that fascinate her and feature in her seductive film *AM/PM*.

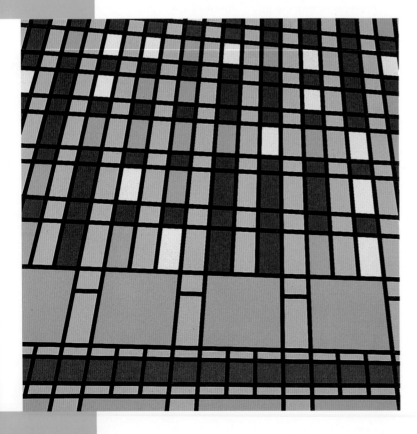

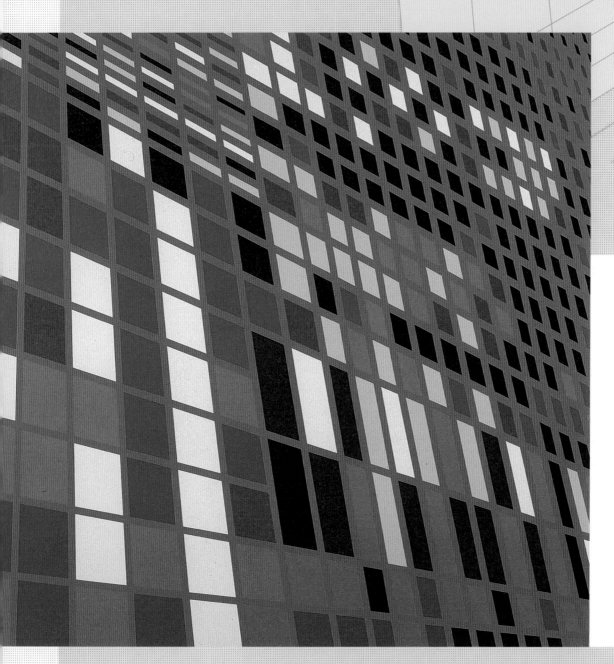

*Midtown - Crowne Plaza
Hotel* 1999

*Midtown-1211-Rockerfellar
Plaza* 1998

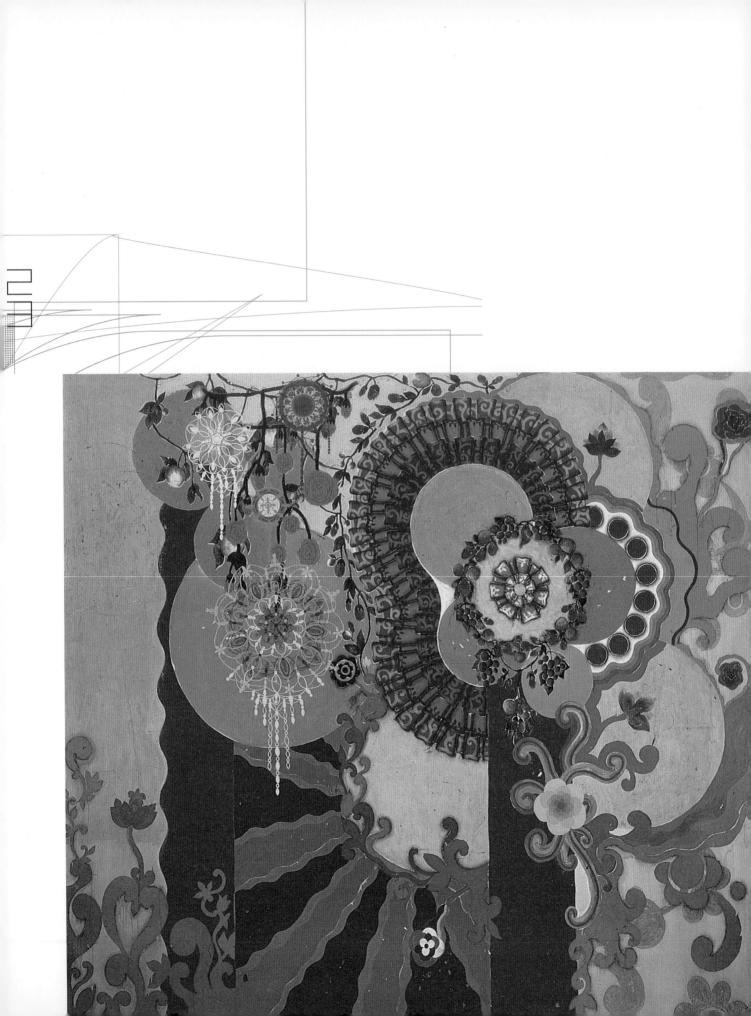

She builds her paintings up through a series of paint transfers from plastic sheets. Once the motif is painted onto the plastic sheeting she decides, after careful consideration, where to apply it to the canvas. She then glues the back of the painted motif to the canvas and peels off the plastic, which often abrades the image giving it a weathered look. This technique of collage and pasting gives her a great deal of freedom in constructing the painting while distancing her from having to create the whole picture by standing directly in front of the canvas with a brush.

The term 'decorative' is often used pejoratively in relation to contemporary art practice. It is as though enjoyment of the body and sensuality are to be kept at bay as intellectually suspect in some way, as if pleasure is too easy an option to evoke through a work of art. Milhazes' work rails against this attitude. It revels in enjoyment and exuberance whilst still having a firm organisational principle within each painting. The Baroque suffuses these works. The space in them is always relatively shallow, pushing the surface out to the viewer by using decorative motifs with a hypnotic, swirling movement that seduces and sometimes cloys. They are paintings that speak of relationships and goodwill through their interlocking elements and jubilant use of colour. They have a living energy and visual invention that can seem death-defying.

A Seda 2000

As Quatro Estações 1997

Born 1960, Rio de Janeiro, Brazil
Lives and works in Rio de Janeiro, Brazil

beatriz milhazes

Beatriz Milhazes' paintings critically address the imagery associated with her country through the dextrous amalgamation of elements of modernist pictorial language and the intensely decorative iconography of Brazilian culture. She uses tropical fauna and flora, folk art and craft, local popular culture, jewellery, embroidery, lace, carnival and colonial Baroque as her major thematic sources. These paintings are luscious and engulfing, but also impose a sense of excess that is disorientating. They engage with the particularity of place and a personal interpretation of that situation being put into dialogue with the language of 20th century painting developed in Europe and North America. Milhazes has a fascination for the arabesque qualities in the paintings of Matisse and many of her paintings incorporate homages to his lithe, arching and decorative lines. She is also concerned with the order and structure found in Mondrian's work and manages to combine both sets of influences into her practice. The resulting paintings feature a hybridisation of forms and histories that sometimes appear familiar and at other times extraordinary alien to European eyes.

Gavião e Passarinho 1998

Minhas Crianças 1999

Every drip and daub is accounted for and often digitally placed, enhancing the artist's ability to manipulate visual material.

The digitised image of canvas weave is used as a motif that binds elements together; it is blown-up in scale and crosshatches the surface of these emblem-saturated works. The possibilities of gesture are explored in images that reveal their narratives through simultaneous time frames. This happens because new images become readable in the work depending upon

several positions so that no one definition will ever suffice. This is indicative of the time we find ourselves in: contingent, shifting and restless but still haunted by the ever-present effects of human desire and death.

Marcaccio's practice is at once insistent and subtle. He understands the philosophical positioning of painting but also sees the pitfalls of relying upon theory in that it can make artwork merely illustrational. His works, by contrast, emphasise the intelligence, subtlety and violence of contemporary vision. They

the viewer's distance from it. From way back the overall effect is one of a powerful gestural explosion, but when we approach the surface of the work we recognise the subtle integration of miniature images within the picture. Marcaccio's paintings pull the viewer's vision in and out of focus: the works move from the macro to the micro with sudden shifts of pictorial scale that make the experience of them highly active. The viewer slips from an appreciation of colour and gesture to figurative narratives that depict sex, lust and violence. His work vacillates between

come out of an intense commitment to visual experience as one that we can attend to in a fuller way than the often reductive stories of aesthetic theory. Painting is a method of expansive thinking that involves the inescapable fact of the body and physical reality. Marcaccio's works seek to become porous and embrace technology in developing visual thought that consistently allows further mutations to occur in the practice of painting.

Graft-Paintant 1999

Brushwork Paintant 1999

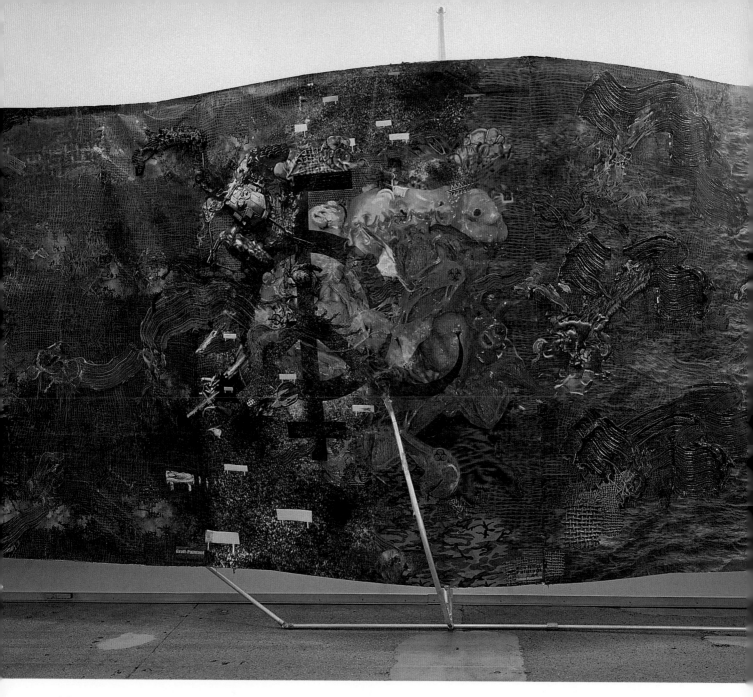

Marcaccio fetishises the brushstroke as both erotic and sensual. His graffiti-like digitised brushstrokes bring to mind the paintings of Roy Lichtenstein in their playful intent and bracketing of painting's processes and myths as a subject in itself. He employs a collage technique to let something new emerge from visual chaos that still has an identifiable fidelity to the tradition of painting. This process parallels the innovations made in contemporary digital dance music with its breaks, cuts, samples, sonic textures and complex new synthetic rhythms. These works embody the culture of sampling that is at the centre of our new visual and aural world. A sample is something we recognise from another context (particularly in the case of recorded music) but is given a new situation in which to operate where its impact is transformed. Marcaccio's works use the child-like, playful activity of cut and paste with its endless renewals that combine our fascination for different stories and combinations of histories about ourselves and the people around us. He demonstrates the embedding process of memory: what lies where, against what and with whom.

Born 1963, Rosario de Santa Fe, Argentina
Lives and works in New York, USA

fabian marcaccio

Fabian Marcaccio produces highly energetic, vividly coloured paintings that exist in the area between violent gestural abstraction and narrative allegorical figuration.

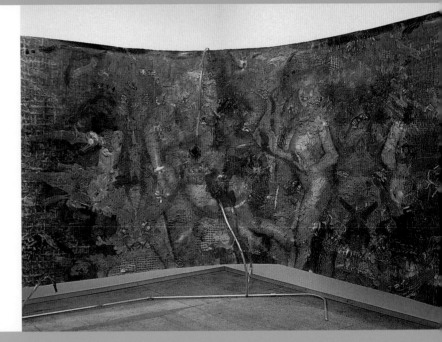

They engage with the history of painting and the way in which new technologies can generate visual information. Marcaccio paints and collages using a computer to manipulate scanned images of political signs, advertising logos, camouflage and photographs of small maquettes and sculptures he has created. After he has worked on the images via the computer he prints them out onto a plasticised form of canvas using a large-scale plotter. He then adds to these printed surfaces with paint and silicon gel to complete the work. His stretchers are sometimes tent-like structures, oddly nomadic and provisional, contorted by bungee cords and metal pipe armatures that protrude from the wall as if the painting were somehow trying to break free of its own boundaries.

Paintant Stories 2000

Les Damoiselles Paintant
1999

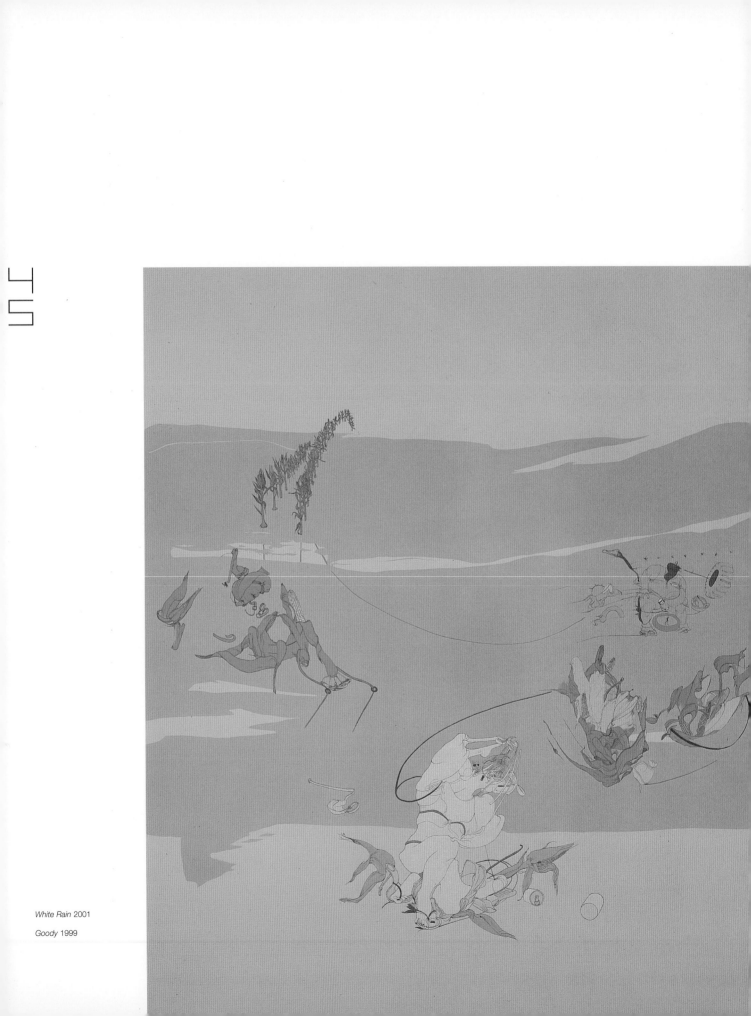

White Rain 2001

Goody 1999

However there is also a form of desire that suffuses these works in their bodily absorption of technology, as though a union has to be forged to achieve satisfaction.

These paintings are closely indexed to the Surrealist work of artists such as Yves Tanguy, Matta and Salvador Dalí. They have the same fascination in depicting a hyper-real fictional world. Essenhigh's works have a clean-cut pristine precision that visually grabs us. This immediacy is carried through in the bold use of coloured grounds, and is then slowed down by the Baroque quality of her line. She sets up a dialogue between these grounds, which are an emptied out space, and the detail that punctuates them. The paintings are reminiscent of a Japanese artist such as Hokusai in terms of extrapolating from nature and simplifying form. Unsurprisingly, in having a Japanese influence, they also bring to mind the clear visual narratives of comic books, which often project the mutation of sciences and augmentation of human powers.

Painting has long had a utopian impulse in helping visualise the future. Essenhigh's works have a fascination for science fiction imagery and augmentation of the human body as a fantasy of immortality and increased power. This is at heart an adolescent concern, but one that we hold onto

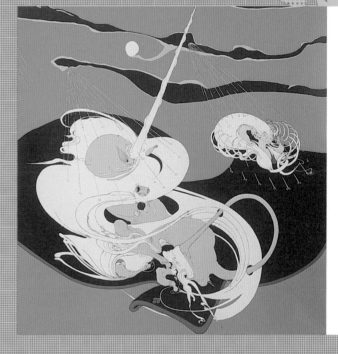

throughout life as we face the realities of ageing and failure. The compensatory space of science fiction allows us to dream surreally and escape reality for a while. However, we are now living in an age where science fiction becomes fact at an ever-increasing rate. These paintings may not look so futuristic in a relatively short period of time. As a constant, they have a formal playfulness and rigour of composition and line that asserts them as convincing works of art firmly indexed to this cultural time of hybridity and technology.

Born 1969, Ohio, USA
Lives and works in New York, USA

inka essenhig

Inka Essenhigh produces paintings that depict mutated landscapes and figurative situations that defy easy description. There is a curious tension between the highly resolved formal aspects of these works, that are cartoon-like in their crisply painted high-key colours, and the unresolved nature of their narratives. Fragmentation and hybridity exist alongside compositional conviction in her paintings. They embody doubt and humour as well as imaginative possibility. They bring to mind the new technologies we are regularly presented with in the media such as genetically modified crops, cloning and ground-breaking surgical practices, but also our unstable relationship to the 'natural', and our own bodies. These works seem to deal with a gradual loss of self and certainty in confronting the future, epitomised by Essenhigh's avoidance of depicting facial features, with which we might identify, for her paintings' characters.

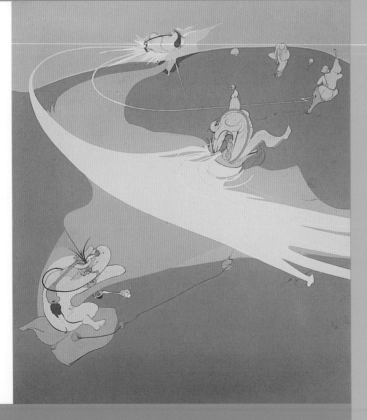

*Cheerleaders
and Sky* 1999

Born Again
1999/2000

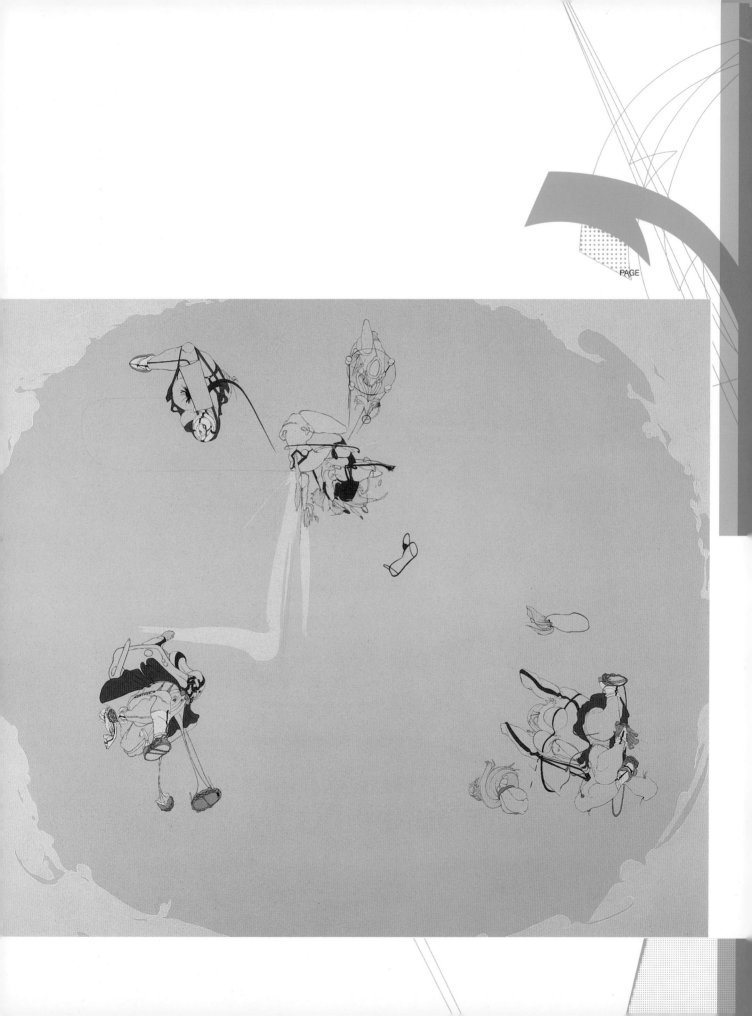

1

represent utopias within painting practice to locate our desires for a better environment and more satisfying way of city living. His work both highlights the structure of urban development and its control by corporate forces. However, Ackermann's paintings and drawings provoke – as a form of aesthetic recovery – imaginative interpretations of the new metropolitan environment and the place of increasing levels of travel in forming our attitudes towards urban life.

Abschied auf See
2000

White Crossing I
2001
Installation shot at Gavin
Brown's enterprise

Ackermann's work forces the viewer to decode and project herself into the depicted scene, as well as appreciate the formal rigour of their construction.

Ackermann's works break clear of given boundaries making use of murals, mirrors, photographs, paintings and drawings. These elements are brought together to play off one another in order to create an effect of excess in developing complex visual narratives. Ackermann's practice is atrophied and parallels the contemporary situation of possibility and information overload. He demonstrates how we build on and

franz ackermann

Ackermann is concerned with what he terms 'mental maps', created on his extensive journeys in various foreign cities. These mental maps are notebook-sized drawings and gouaches from which architectural landmarks and abstract patterns emerge in recollection of a sense of place. These operate alongside, and sometimes help develop, larger scale oil paintings. His work is engaged with the psychogeographical ideas and urban criticism implicit in the International Situationist movement and much of his practice has a florid, almost psychedelic, cartography that conflates maps of imagined places and the experience of reality mediated through painting.

The Studio in the Desert
2001

Untitled (pacific no 14: no one will ever obstruct your view) 1998

Once Ackermann has chosen a place to investigate, the key thing becomes a discovery and interpretation of the city's sense of structure through walking and looking. Anything that represents a city such as a photograph, postcard, newspaper picture, town plan or tourist brochure can find its way into one of Ackermann's gouaches and, possibly, later into an oil painting.

His dense and interlocking paintings and drawings use layers of imagery that parallel contemporary urban vision in their intensity and eclecticism. His work is full of propositions allowing abstraction to be rooted in lived experience that is at once aesthetic and political. His work engages with a nomadic sense of place, always restless, contingent and somewhat breathless. This is, in part, the experience of the tourist flâneur, forever on the outside, hyper-aware of difference and novelty in a new environment. The ideal city, Ackermann's work asserts, is one that consists of nothing but sheer activity and energy, so these works thrive on a degree of disorientation in the creation of a subjective cartography. The activity in

with the use of tactical inversions which his paintings inevitably feed upon. Within his larger installations, like Reed's and Ackermann's, the effect is one of disrupting the viewer. Marcaccio has moved through various strategies, from engaging the structure of the traditional wooden support in a kind of 'feedback' situation, to nomadic supports of make-shift copper-tubing and tent-like skins, and more recently to large steel architectural frames which, almost aerodynamically, provisionally locate and encase the paintings. Combined with the continuous multiplicity from texture to image and back again within these individual screen-like, elongated painterly events, the overall structuring causes a disconcerting vertiginous sensation. It is a radical questioning of the location of painting today which is asserted by Marcaccio.

While painting, yet again, has been mercilessly thrust into the curatorial limelight as 'back in town', the present exhibition proposes painting in an expanded, unbounded and yet self-critical light. If colour and abstraction are key touchstones to this particular grouping of artists, then these issues are dealt with in a manner which opens out the prescribed limitations of inherited traditions. Most of the works on show here ask important questions about how painting can function beyond its narrow institutionalised status, questioning the very assumptions which attempt to define it, crudely pigeon-hole it, or see it as 'completed' etc. It achieves this not by programmatic, institutional or ideological critique, but rather via working on, and through, form itself.

If the hybrid essentially cuts across, or combines, different species or varieties, then perhaps the collapse of the artificial separation and critical polarization – within the last few decades of the 20th century – of Matisse and Duchamp takes on a new urgency for painting and its relation to the everyday. If the possibility of thinking across these two positions is rather like an oxymoron, then it is one that provides the fuel to explore

fresh terrain. Abstraction as it is articulated within the present context, suggests on one level, the dissolution of exclusive medium-specific notions. Even Clement Greenberg conceded, in a rare moment of critical modesty, that, "The classic avant-garde's emphasis on 'purity' of medium is a time-bound one and no more binding on art than any other time-bound emphasis."** To this we might add the old dialectical oppositions of figurative/abstract or representational/non-representational, and the irreducibility of abstraction to primary essential forms or idealistic informing structures which now appear useless in the face of changed conceptions of structure itself. If a model of abstraction is relevant to these artists then it is one which no longer 'turns away' from the world but is active in its intensification; it favours connections and hybrid articulations, as John Rajchman, back in the mid 90s, suggested:

*'The relation between mediums (and abstraction in mediums) is one not of negation but of connection, of 'and' rather than 'not.'... For this world is what abstraction is all about: abstraction is the attempt to show – in thought as in art in sensation as in concept – the odd, multiple, unpredictable potential in the midst of things of other new things, other new mixtures.'****

Such a proposition is actually inscribed within the work on view in this exhibition. In particular, the potentiality of a world of work which is no longer held hostage to notions of either conceptual, or visual purity, denotes a new, invigorated alignment of mediums, sensations and conceptions. Painting, in fulfilling its capability in this role, becomes an interface of endless possibilities.

** *Clement Greenberg 'Counter Avant-Garde' Art International, May 1971*

*** *John Rajchman, Constructions, Cambridge, Massachusetts, 1998, pp.75-76*

random configurations with massive shifts of scale within the same canvas. The viewer in this context becomes a performer or operator – assembling something that is impossible to assimilate in one look.

Formed from a very different perspective, Beatriz Milhazes' paintings might at least share this notion of a proactive viewer with some of the more florid and complex Cohens of the early 1960s. Intricacy and detail accompany her hypnotic decorative forms in which – as in the colonial Portuguese Baroque – a stable, cohesive perception of a composition is denied. It is a complexity that eludes the instant. Yet this does not result in chaos, as Milhazes' worlds are strictly ordered and built. Once within these works the eye is forever on the move around pockets of 'excessive' ornamentation. Decorative motifs are allowed to waft across each other, interconnect and freely associate. In *As Quatro Estações* of 1997, rosace forms, floral fresco-like decorations, flattened gold-leaf circles, form a whole of contrasting atmospheric connotations. Drawing on the traditions of craft and hand painted wall

decorations, these paintings also possess a strong sensation of time, asserting another sense of temporal depth, of historical patination. Surface becomes subtly activated and motivated by these forms, which in turn reveal themselves to be – in an odd paradox – luminously present and strangely distant.

Monique Prieto's near perfect surfaces of raw canvas lay host to forms that are, again paradoxically, not exactly locatable and yet disconcertingly familiar; these images play with the legacy of 1960s formalism, overturning the 'rules' into a playful narrative of form, rather like Morris Louis-meets-*South Park*. Conjuring up associations such as soft bean-bag sculptures, these individual forms appear to operate with a sense of gravity, of individual 'ontology' almost defying the logic of the stain and its behaviour on the surface. Using the computer software *Painter 3*, Prieto moves between these abstract figures having their own sense of weight, to operating as freewheeling Rorschach shapes, while sometimes amalgamating both states. Colour, is very particular in Prieto's pictures, and she works closely with the digitally formed shape and its attendant hue, forming icy cool pastels occasionally shot through with an intense blood-red accent or motif.

Colour within the scope of the exhibition as a whole, is a key element, and, to arrive back at my initial starting point, the work of Fabian Marcaccio might well be instructive in this instance. Marcaccio has acknowledged his extremely artificial, synthetic approach to colour, in terms of what he refers to as 'disjunctive' operations: "The artificial is always related to our constructed notion of the natural" he insists.* Colour, here, goes beyond the modernists' insistence on primaries, or simply appropriating the fashionable colours of the day. Marcaccio creates a shifting situation principally based on impure secondary colours that reflect the sheer flow and velocity of transformation which occurs in the work, together

Bernard Cohen
Matter of Identity, 1963
© Tate, London 2001

*Dialogue with the author,
Fabian Marcaccio/Jessica
Stockholder,
Sammlung Goetz, Munich p.32

simple art historical operations of genealogy and taxonomy.

Morris' *The Mirage [Las Vegas]*, which might serve as an example of this temporal depth, returns the unstable vagaries of reflection back to the structures which enable them. It congeals the material surface and the play of light in a concretized unified image. Such an image encapsulates a basic coding of modernism in terms of the grid or the systemically articulated field; also, perhaps, the work of Pop artists – such as Patrick Caulfield, for example – might spring to mind. I am not suggesting here that Morris has consciously used such a reference, but that the paintings intimate a kind of 60s or 70s 'atmosphere' or mood. The fact that this period operates as a kind of conscious or even unconscious touchstone for many of these artists is significant.

Earlier in the last century Walter Benjamin pointed to the complexities of fashion and how an invocation of a past fashion or style can in fact operate as a fecund site of revelations for the present. Antique Rome was, for Revolutionary France, such a proposition; leading to fashions of dress, theatre, painting and all manner of items. It could, for a short time at least, cut across divergent camps – Marie Antoinette caused a sensation wearing an austere minimal linen dress in a pre-revolutionary courtly event, while Robespierre and David used it to tap the Republican ethic which would bring her rapid downfall. Closer to home, back in the 1980s, Peter Halley made a convincing case of why the 60s were relevant to his practice; it was, for him, the 'perspectival' vanishing point of the contemporary world. It was here the seeds of the 'current' climate were planted; the serious development of the new technologies and the financial markets, the seeming origin of certain social trends, and an intensification of popular culture. It remains a credible reason – beyond Halley's own output – why this period continues to haunt contemporary practice in this particular way. It is often neither graspable on the level of

literal interpretation nor analysable from a specific ideological vantage point. To go back to *The Mirage [Las Vegas]*, despite its reduction and aggressive simplicity, it is also highly evocative of this hybrid temporal depth.

Certain aspects of 1960s paintings, partly because of resurrections in style, appear strangely 'vivid' once more. As an example of this, an artist like Bernard Cohen might appear as a case in point. Producing work that could not be fitted comfortably into either of the Pop/Post-Painterly Abstraction camps that informed the period, his earlier paintings appear uncannily contemporary. It is the 'impure' nature of Cohen's forms which engage, and his wealth of intimations of the everyday. Using references to the cinema (as architectural containers), his own collection of Art Nouveau lamps and objects, food and other allusions, Cohen developed a vast array of forms. His knotted, arabesques are gestural figures which have generally become almost emblematic and ubiquitous of late – perhaps because of their status as indeterminate, involuted, and non-hierarchical visual events. By 1963 these figures are allowed to float and intertwine in seemingly

authentically engaging in its exploration. This tension between the administration of urban space and the individual's potential re-appropriation of it lies at the heart of Ackermann's enterprise. His 'mental map' series of drawings, which are made on-site in the visited locations, sit somewhere between the two – using the given cartography of a specific place as basic material for free, highly subjective, variations and improvisations.

Ackermann's individual paintings are intense and psychedelic; fragments of visual urban residues such as buildings, pathways, drawn routes or mappings, architectural close-ups, and congealed spaghetti-like circuitry, punctuate a florid, pulsating field of organic colour patterns. Yet the 'work' as a whole cuts across numerous ways of both addressing different media and their presentation. His larger installation projects draw together these pieces that reflect different aspects of his practice: paintings (from the studio), photographs as record (from particular locations), or appropriation (from travel brochures or the press), drawings (of experience on site), slide projections, architectural amendments, and wall painting which acts as a binding element for these heterogeneous components.

Sarah Morris' painting also references the structuring urge of the contemporary city, and while on the surface they might appear the extreme opposite of Ackermann's sensibility, they too share a sense of the interchangeable nature of metropolitan centres and the drawing together of fragmentary experiences. New York-style skyscrapers now inhabit the skyline of every major city; the same chain stores or architectural ventures reside in Tokyo, London or Manhattan. Morris is concerned with how highly coded information can be reduced to stylised graphic signs. Her recent work references the huge blank, reflective surfaces which proliferate in urban experience, as familiar to us through cinematic stage-setting as from our day-to-day

negotiation through the city. Like many of the other artists in the exhibition she moves freely between media (she has described her film *Midtown* as a 'condensed manifesto'*) utilising film as a common point of reference for the artist and audience alike. The painted series *Midtown* reflects the vast structural logistics of modernist architecture, but Morris is keen to add, 'I'm more interested in corporate hotel design than Le Corbusier, although you can't get one without the other.'** These paintings take fragments of urban visuality to an extreme. Interestingly, the vantage point of the photograph remains integral to these images, becoming highly saturated, encoded abstractions; parts of a 'broken narrative'.

John Cage, the American composer, speaking of the experience of the modern city, once suggested that:

*'The greater use of glass in our cities – greater say than in the 19th century – has led to our experiences being complex and 'in collage' so to speak. So, a 19th century idea like 'the more experience you have with a given work of art, the more you will understand it' – you remember that idea? – is no longer true. Now we have a different attitude, which comes from these reflections and transparencies. We realise that each instant is unique. We don't have to go to those 19th century depths.'***

Cage's ideas, here – that we exist in a situation of 'collage', that 19th century depth is no longer available to us in the same way – have, of course, been wrestled with, and ingrained within artists' consciousness for some time. For instance, Sarah Morris has suggested her choice of utilising household gloss paints rather than traditional materials was a means of replacing the weight and depth of art historical reference with the surface lure of the commercial world. We can, however, think of another type of depth which is present (other than Cage's citing of a 19th century notion), it is a synchronic or temporal depth which accompanies many of the images in the current exhibition and goes well beyond the

*Sarah Morris interviewed by Michael Tarrantino and Rob Bowman, 'Sarah Morris Modern Worlds', Museum of Modern Art Oxford, 1999

**Ibid.

***Interview with John Cage, Art and Design Magazine, Art meets Science and Spirituality, issue No.21, Vol.5, No.6, p. 49, edited by Johan Pijnapple

Tobias Rehberger
Yam Koon Chien 2000,
from the installation *Nana*,
Neugerriemschneider, Berlin

fictional image within, and amongst, a host of others.

Captivated initially by the light in *Vertigo*, Reed has gone on to produce several installations based on the character Judy's hotel bedroom. In particular he has focused on the moment when Judy emerges from the bathroom dressed – at Scottie's (James Stewart) suggestion – in Madeleine's outfit. What appears to fascinate Reed is the coalescence of the two characters – Madeleine/Judy – at this very moment, and the exchange within the intimate constraints of the room itself. Hitchcock's room is in fact a fictive space in itself. Even though the Hotel Empire exists in San Francisco (though no longer by name), the scene of the walk from the bathroom traverses a location shot in the Hotel Empire and a studio location elsewhere. Reed implies that this labyrinthine layering of fictive cinematic space is an extension of those already existent in the paintings themselves.

To play with illusion, and especially the relationship of memory to the everyday – as do both Reed's and Hitchcock's work in their own different and yet intertwined ways – is to stress the realm of fantasy and the virtual. How, in fact, our memories function as a complex overlapping of virtual images, which inevitably gain independence from their origins in reality. This has been extravagantly and amusingly affirmed by the contemporary German artist Tobias Rehberger, to take an example outside of the current exhibition. The artist presented hand drawn two-dimensional images, done entirely from memory, to the manufacturers of the Porsche 911 Carrera and the McLaren F1 sports cars for realisation. Both these cars represent luxury items and remain hybrids even in their original form, developed as they were through adding parts to inherited formal designs. What was actually constructed deviated from the original in a number of distinct ways, and while Rehberger insisted that his cars were to be in working order, the functional aerodynamic principle of the originals was lost. Rather like giant toys, these cars were the result of a compound of memories congealed to form a particular image. Fellow countryman Franz Ackermann applies a similar logic to various urban locations that he visits. His large installations suggest an amalgamation of place, urban experience, and its interface with mental life. Such an outlook has roots that stretch back to the dawn of modernism – from which the modern city emerges as a huge machine, processing difference in very particular ways (here, we can think of the structuring of 'immigrant' or financial districts, the suburbs, or the supposed 'liberation of expression' associated with the great metropolitan centres). In this sense, every city is an agglomeration of impurities, which nevertheless requires a 'concept' of itself in order to remain readable or usable. It is the most artificial of such concepts that is made available to the tourist of any large city; and it is here that Ackermann identifies his practice in order to reflect on the duality of being 'processed' by a particular place and

Essenhigh's paintings give these issues a techno or cyber-twist, but remain not unrelated to the radical collage of the 19th century Gothic. Shelley's *Frankenstein*, that proto-hybrid, remains almost trans-historical in its significance. Its relevance goes way beyond – and despite – its iconic status within popular culture. It might well now be invoked to describe our anxiety over genetically modified food, or any other 'inhuman' issue, but Shelley's original text does more than this; it remains a complex narrative reflecting on issues which were soon to be grounded within modernism itself. It has been suggested that on one level the creation of this monstrous invention was born of a desire to escape the oppressive weight of her illustrious parents' literary achievements which accentuated her own creative impasse or block.* Shelley's monster – which was suggested to its author by a dream – has of course no such parental lineage, and is an autonomous creature constructed from spare, anonymous parts. As a nightmare of 'pure autonomy' the creature is thrust into the world skipping the formative years of childhood, an 'other' who can observe the ways of the human world afresh. It remains a parable of scientific progress, autonomy, the modernist 'blank slate', and inter-textuality, and serves as a reminder that the hybrid is often clearly associated with the disconcerting, the uncanny, or the monstrous.

Uneasiness in the face of this 'fusion' (of the 'impure' monstrous) can be dealt with in different ways. Canonically, it is related to the operations of the dream work in Freud, which synthesizes and displaces repressed events, moments or memories into hybridised, condensed symbols or signs. The fear and anxiety of the monstrously impure symbol which invades the dream or the nightmare, has been interpreted within Freudianism, as a set of contradictory impulses generated in relation to repressed desire. The hybrid's function, therefore, in this context, is the masking of desire, of psychically manufacturing its mutation into something else. Yet at the same time, the potentiality of this unmasked, unleashed desire exacerbates the inhibiting mechanism of

repression which in turn generates the intense fear and anxiety associated with the nightmare. In order to emulate the effects of this, classic cinematic 'monsters' play on the hybrid, or the metamorphosis from one state to another, therefore generating anxiety, and locating a kind of simultaneous fascination and repulsion. So while Freud, within psychoanalytic theory, wants to unlock the puzzle, to pick apart the hybrid into its readable components, and thus place us back in the sphere of the logical and the 'pure' rationale, the horror genre – and much contemporary art it should be added – simply rides on the frisson of ever mutable and combinable figures.

David Reed has long been involved with aligning abstract painting with various 'exterior' subject matters, including the cinematic. His references range from an engagement with Hitchcock's *Vertigo* to the various genres of the vampire movie. It might well be asked what links these dual obsessions to the activity of painting? The answer would have to lie in the play between material and immaterial forces within both these references. Instability underlies the central characters in these films; whether the vampire itself, or the seeming reincarnation of the dead in *Vertigo*'s Carlotta-Madeleine-Judy 'composite' figure, each in its own way questioning the notion of graspable material presence. Reed himself has acknowledged this allegiance with the fantastic or the 'uncanny', where the experience is one of a loss of presence: "In this category, one can't tell what is physical and what is illusion; the two become merged. One goes back and forth between interpretations."** To place abstract painting in this context, dissociates itself from a materialist or positivist reading, and stresses its chameleon-like nature in a world of images and electronic media. Painting becomes yet another phantom through the dominance of the latter, and Reed sets up possible vampiric, parasitic relationships with such mediated images. Through digitally inserting his own paintings into video footage of these films, they become one

See Elizabeth Bronfen 'Re-writing the Family: Mary Shelley's Frankenstein in its Biographical/Textual Context' in Frankenstein, Creation and Monstrosity, ed. Stephen Bann, London, 1994

**
Conversation with the author, May 1996

David Ryan **hybrids**

Once denoting 'exotic' or radical displacements, such manoeuvres are now integrally part of the fabric of our lives. Surrounded, as we are, by cut and paste edits, as well as seemingly homogenous products which traverse media, temporality and location, objects are no longer reducible or readable in relation to their 'pure' basic components. The whole question of 'pure' forms or 'origins' now seems misplaced. Transposed to the level of painterly practice, this 'developed' collage might be the key to offer some insights – albeit from very different perspectives and outlooks – into the work of this current grouping of artists.

Within the paintings of Fiona Rae, a similar proposition might be found. In the past, Rae's images have often been discussed in the light of a kind of 'pick-and-mix' aesthetic – or taken as a patchwork of quotes. While the marks or passages in the paintings have brought to mind art historical or popular references, they rarely enter simply a system of quotation per se, and often morph one allusion into another. She has always stressed her sense of making these her own, of 'speaking through' such allusions, rather than a passive practice of appropriation. Her development of specific series of works over the last few years, displays her virtuosity in framing various tensions and contradictions that creatively feed the work. The series of elongated paintings using circular target motifs is a case in point, or another, more recent, set on black grounds with a choreographed interplay between gestures and formal rectangular floating frames. Highly wrought paintings, the latter set display Rae's increasing sense of discipline without jettisoning play or improvisation.

Rae's gestures remain eloquently displaced, rather like a conscious ruffling of Abstract Expressionist 'grammar'. Painting acts as a magnetic field here, suggesting a delicate and precarious balance between what is generated as figure or ground, together with almost scatological references to popular culture. It

remains, however, the urge to create a new sense of totality and unity from these disparate events which continue to compel, further distancing Rae's activity from the simplicity of a cut-and-paste, pick-and-mix collage approach.

In Inka Essenhigh's paintings, her persistent use of a kind of literalised figure/ground relationship (humanoid form/landscape setting) develops a drama between spatial context and their ambiguous protagonists. It is a 'camp' drama, one which is played out within the space of the computer game or the individual comic book frame. Informed by a glaring enamel based sheen which entraps both the colour and drawing into a skin-like surface, Essenhigh's paintings suggest a relentless connectivity between inanimate things, artificial intelligence and composite humanoid shapes. Headless figures – deprived of the existential and expressive communicator of the face – become entwined in a narrative over which they seemingly have no control. Electronic flex binds divergent organisms and devices, while the 'landscape' of the ground itself might appear as a cosmic splurge, or, at times taking on the identity of a psycho-sexual plasmatic terrain complete with orifices and protrusions. Invariably these works have invoked the world of the cyborg – the merging of the human and the technological. The cyborg is the ultimate site of a loss of identity through technological enhancement – whether this relates to the organism's gender or distinguishable 'human' traits. Cyber-sublime, the space of these paintings suggests a new arena for staging the body, a space where binary oppositions have melted or merged. Essenhigh depicts this as a tragicomic virtual world whose actualisation is, in fact, anybody's guess.

Essenhigh's depiction of mutant figures in wondrous landscapes brings to my mind certain passages in Mary Shelley's *Frankenstein*, where the Monster haunts the frozen vast landscapes of Switzerland, a merging in itself of very different aspects of the sublime or the uncanny.

Imagine this: a photographic image of a flower head and its stems seemingly crushed by a series of bravura Abstract Expressionist brush strokes. The Argentinean painter Fabian Marcaccio has provided us with such an image: his *Conjectural Amendment (Untitled)* of 1996. It is a violent image in its own way; one that, at first glance, might well conjure up a violation of nature, or might be seen to speak of contamination or pollution. And yet the link between these two contradictory elements, on closer scrutiny, is not so simple as a natural 'ground' contaminated by the 'figure' of a cultural polluter. Both are intrinsically linked on a basic level as 'given' embodiments of pigmentation: one synthetic and the other natural. Yet we can no longer point to one or the other with the assurances of either category (within the picture or outside of it) and are left with increasingly blurred boundaries between the two. Here, the technology of paint production and genetically modified flora merge into the same horizon.

It is typical of this particular artist, and the others included in this exhibition, to explore previously mutually exclusive motifs or categories, which are allowed to interpenetrate and collapse into one another, creating a space other than the binary exclusions of a purist logic. In Marcaccio's case, his paintings are wilfully complex, consisting of multiple compounds, and straddling traditions, attitudes and modes of painterly practice, mobilised not simply as conflict, but in order to find a new cohesion. While this might distantly relate to the now classical figures of collage/montage, it is, as he puts it, a 'healed collage'; the biological metaphor is apt, as it points to a shift of emphasis away from the cut or the graft in itself (i.e. the shock of Surrealist juxtaposition or combination) to a more seamless passage between differences. He positions this in contradistinction to the traditional uses of collage while at the same time seeing it existing as a mutated distant relative. Raymond Williams once suggested that the radical de-familiarisation of montage had found its ultimate destination in the form of the TV commercial, something that Marcaccio also suggests:

'…the ultimate banality of collage is perhaps the 24 hours a day collage on MTV. Right now the world itself is a disparate collage, and communication technologies have made it possible for international industries to produce collaged products, by utilizing workers, materials and means of production in many different countries, without respecting any provisional local orders, at will. Our generation is perhaps the first one to try to integrate or organise something after this now established all-over cultural collage.'*

* 'Dialogue between Fabian Marcaccio and Jessica Stockholder', Fabian Marcaccio/Jessica Stockholder, Sammlung Goetz, Munich, 1998, p.53

improvisatory issues through the work of some of the most interesting artists painting today. The exhibition focuses on how particular personal and cultural histories come to bear on the practice of painting, resulting in a rich iconography that extends the language of abstraction and figuration in unexpected ways. These painters are hyper-predatory: they use myriad sources and influences in their practice so that everything appears up for grabs. The work in the exhibition pushes the boundaries of painting to build upon and transform the modernist tradition, which itself was built upon acts of subversion and consolidation. The exhibition allows an exploration of what painting picks up and uses in extending its language and re-engaging the viewer with everyday life.

Many of the artists in this exhibition make reference through their painting to other technologies and disciplines for picturing and interpreting the world: they are fascinated by surfaces that are alien to painting. These comprise mediums such as film and digital imaging – with their compression, editing and folding of time and use of intense colour – sampling, map-making, graphic design, fashion, urban architecture, comics, photography and the exploration of scientific theory. These painters bring many art historical elements into their work including Pop Art; Post-Painterly Abstraction; Abstract Expressionism and Surrealism – but each of them also employs references from their own individual cultures. This exhibition highlights that tradition is always open to the imaginative interpretations of artists. It emphasises a double movement within contemporary painting: *abstraction* as an activity *drawing from* both the visual world and experience, and *hybridity* as a *drawing together* of different narratives in the creation of something new. Hybridity allows different cultural and technological issues to be explored through the language of painting.

So what do painters now allow into their work? What has happened to the supposed purity of abstraction and its attendant, life-denying,

morbidity? The truth is that there never was any real purity, we are too enthralled by the visual world to achieve such an emptying out of ourselves and single-minded sense of purpose. We are inescapably bound to the visual; it permeates our lives. We can never see enough, which explains the increasing sense of horror and prurience that drives the media. It is this spirit of visual surfeit with which the artists in this exhibition work. They have to negotiate a path through, and into, the contemporary visual realm. All aspects of our lives are now mediated giving painters a maximal, expanded field of operation. The stories that situate us and allow us to see past and future are cross-infected: different cultures now inform one another in ever more subtle ways, as reflected by the works in this exhibition.

worked through in many different painting strategies. They are isolated, parodied, played-out and eventually reinvented by successive generations of artists. As viewers, we constantly reinterpret historical painting in our encounters with it. It throws new light on material culture and our hierarchy of interests. A good painting is evidence of visual thinking in one of its most sophisticated forms. It is subtle and lithe and opens up new mental vistas for us through an engagement with the provocations offered by technology and changing notions of selfhood.

Another important precedent for the current situation is the late work of Philip Guston who, in 1970, after being considered a pre-eminent Abstract Expressionist painter suddenly presented a group of new figurative works featuring cartoon-like imagery that dealt directly with what was most personal to him. This body of work resisted the theoretically driven imperatives of modernist theory, espoused by critics such as Clement Greenberg, to become a new paradigm for freedom and eclecticism, emphasising that painting does not have to look a certain way. The work of all of the artists mentioned previously, signified, in diverse ways the continuing strength of painting, to adapt, hybridise and reflect new circumstances. Their work demonstrates that traditions of any sort are a resource and offer the conditions of possibility for developing a practice. These artists established the ground rules and act as a starting point for improvisation.

Hybrids offers an opportunity to engage with the contemporary manifestations of these

Philip Guston *Monument*
1976 Tate, London
© 2001 Philip Guston

Simon Wallis **introduction**

grown used to having sensory experiences without yet having a language for them: theory no longer holds any hypnotising grip upon practice. Our time is characterised by the use of technologies making the world, and our interpretations of it, ever more spectacular and fantastically manipulated. But whatever the state of the current historical situation, painting remains a porous activity, sensitive to all the complexities of a living person's relation to his or herself and their immediate environment.

This situation has precedents in the Cubist experiments of Braque and Picasso in the early part of the last century, where printed media and real objects were directly incorporated into their paintings. These works featured collaged typography from journals, newspapers and commodities of the day, as well as depictions of objects of leisure such as musical instruments, pipes, books and playing cards. All these elements were situated in a new kind of space that was fragmented and multidimensional. These works operated as an early form of sampling, which is now a familiar process of

recontextualising a visual or aural element from its original source into a new situation that enhances its particular quality while creating a new network of meanings. This is a strategy at the centre of contemporary creativity. Other historical precedents include the Futurists who had what remain very contemporary concerns with technology, speed, warfare and utopias. Alongside this, the work of painters such as Mondrian and Malevich started to contribute towards visualising a modernist, rational space that reflected new modes of production and politics, architectural environments, design and typography and their symbiotic relationships to one another.

Mondrian in particular can be seen as a quintessential hybrid painter. This is typified by his late New York paintings of the 1940s, which distil the urban experience of a European encountering a modern grid system city and the new hybrid musical forms of jazz. Mondrian's visual experimentation still sets a paradigm for current painting practice. His work asserted a vision of the future that has now become part of our everyday vernacular. His wish for painting to dissolve into the fabric of everyday life has in many ways come to pass through its use in the media, interiors and the fashion world. However, it is a dialogue – painting both shapes vision and adapts and hybridises what is at hand by recycling visual information into new forms. Mondrian's art was one that played an end-game with painting, it prophesised a death that was never to come. Painting now has no such sense of morbidity; rather it is suffused with the possibilities opened up by technology and a contingent, pragmatic, acceptance of life experiences.

After Mondrian's fascination for the urban we encounter the visionary forces of Abstract Expressionism, Post-Painterly Abstraction and Pop Art. This is the beginning of the process of hybridity reacting to the new visual complexities of the political, commercial and social world. High and low forms of culture are addressed and

Piet Mondrian *Composition with Red, Yellow and Blue* circa 1937-42
Tate, London
© 2001 Mondrian/Holtzman Trust c/o Beeldrecht, Amsterdam, Holland and DACS, London

'The painter's world is a visible world, nothing but visible: a world almost mad, because it is complete though only partial. Painting awakens and carries to its highest pitch a delirium which is vision itself…' Maurice Merleau-Ponty, *Eye and Mind*.

This exhibition brings together eight contemporary painters from North America, Brazil, Britain and Germany whose work, although diverse and highly individual, shares common concerns in extending the art historical language of abstraction and figuration. They do this by bringing an inventive engagement with other media, technology and urban life to bear upon their work. This dialogue is what gives these artists' practice the quality of hybridity. The hybrid painting is one that develops and reinterprets given historical boundaries by reflecting contemporary concerns and attitudes to the organisation and generation of visual experiences. These paintings are eclectic in what they make use of and this exhibition examines and compares the different processes and strategies used by these artists.

The complex visual thinking achieved in painting can enable us to feel more embedded in the everyday world, as well as affording us the possibility of projecting ourselves into otherwise unimaginable spaces. Painting is a source of pleasure and it also solves problems, both for the artist and viewer. The problems it addresses are myriad and always open to the diversity of our own interpretations. So how might we use the experience of looking at painting, and how do we accommodate it to our personal histories? What does it mean to think visually and for a painter to think via the act of painting? These are questions that are at the heart of our ongoing fascination for the medium. They give painting a use-value and a purpose beyond mere commodity and the often frustratingly shallow question of style.

Although painting is subject to the vagaries of fashion, it mutates in fascinating ways and continues to have a dialogue with all the other proliferating technologies for depicting the world. It has an inventive freedom and the ability to constantly reinterpret itself. But what is now happening to painting practice given our current surfeit of visual information, where attention spans become increasingly fragmented? We're now seeing signs of the nervous system being radically reshaped for a new kind of sensory condition largely found in the digital cultures that influence music and all forms of design and marketing. There is a whole generation that has

While occupying distinctly individual positions, these painters display a heightened sensibility to contemporary visual culture and the rapid succession of creative fashions and trends. This is combined with an openness to revisiting overlooked stylistic models drawn from the history of twentieth century art and beyond. What connects these diverse artistic personalities and oeuvres, is a parallel interest in contemporary urban environments and the effects of alternative perceptual realities generated by proliferating communication networks and sophisticated image manipulation. At the same time, these artists integrate personal histories and localised traditions into their practice, manifesting a cunning capability to fuse myriad layers of information into commanding visions of contemporary experience.

The rigid ornamentation of corporate skyscraper façades, the hypnotic seductions of television, computer and cinema screens, abstracted cartographic representations of metropolitan conglomerates, an isolated brushstroke lifted from a twentieth century painting or a decorative pattern emerging from a contemporary folkloristic artefact, might all serve as stimulation and reference points in these artists' painterly enquiries. In this context, rigid notions of abstraction versus figuration have become obsolete as exacting geometric patterns or amorphous psychedelic forms may allude as much to a specific architectural or urban situation as to the abstract dynamics of interpersonal relationships or economic and social processes.

It is the painterly translation of these diverse elements into compelling and original works that reveals hybridity as a significant and consistent characteristic of the artists' work in this exhibition.

Whether confronted with a single canvas or enveloped in an expansive three-dimensional environment, the painters in **Hybrids** communicate their complex ideas with the punchy immediacy and visual sophistication most often encountered in the pop-cultural domain of advertising, fashion and film. They revel in the intensity of dazzling colour contrasts and sensuous brushstrokes, indulging unashamedly in the tactility of surface effects and the opulent glamour of glossy paint.

Our thanks go, above all, to the artists who have created new works and installations for Tate Liverpool. We are also extremely grateful to all the lenders who have generously supported the exhibition by allowing us to borrow their works. Our sincere thanks go to the following for their invaluable help and enthusiasm in organising this exhibition: Mary Boone and Ron Warren at Mary Boone Gallery, New York, Marion Klein at Galerie Rolf Ricke, Cologne, Tommaso Corvi-Mora and Marianne Basualdo at Corvi-Mora Gallery, London, Randy Sommers at Acme Gallery, Los Angeles, Victoria Miro and Glen Scott Wright at Victoria Miro Gallery, London, John P. Lee at Gorney, Bravin and Lee Gallery, New York, Claudia Altman-Siegal at Luhring Augustine Gallery, New York, Alex Bradley and Irene Bradbury at White Cube, London, Jochen Volz at neugerriemschneider, Berlin, Patricia Kohl at Stephen Friedman Gallery, London, Karla Camargo at Galeria Camargo Vilaça, São Paulo, Deborah Marks, Dean Daderko, Diane Bliss at Bliss Fine Art Services Ltd., New York, Isabel Soares Alves at the Museum of Modern Art, Sintra, Juliette Moir at Thea Westreich Art Advisory Services, New York, Galerie Bob van Orsouw, Zurich and Max Protetch Gallery, New York.

We also thank DED Associates for their innovative catalogue design.

Christoph Grunenberg
Director
Tate Liverpool

Over the last decade, the essentially pre-industrial practice of painting has proven miraculously vibrant and meaningful; revealing once again painting's inherent potential to communicate complex ideas with iconic simplicity. For **Hybrids**, Simon Wallis, curator at Tate Liverpool, has assembled some of the most exciting and innovative contemporary painters from around the world. Tate Liverpool is proud to present the work of Franz Ackermann from Berlin, Inka Essenhigh, Fabian Marcaccio and David Reed from New York, Beatriz Milhazes from Rio de Janeiro, Sarah Morris from London and New York, Monique Prieto from Los Angeles and Fiona Rae from London.

contents

Thanks to the following Tate Liverpool staff who have helped realise this exhibition, particularly Victoria Pomery, Liz Hawley, Natalie Rudd, David McNeff, Helen Stalker, Ken Simons, Barry Bentley, Mary Bustin, Wayne Phillips, Jemima Pyne, Claire Young, Tracy Ruddell, Elisa Oliver and Catherine Sadler.

hybrids

International Contemporary Painting

This catalogue is published to accompany the exhibition

Hybrids
Tate Liverpool
6 April – 24 June 2001

ISBN 1-85437-379 X

A catalogue record for this publication is available from the British Library

Published by order of the Trustees of the Tate Gallery 2001
Tate Gallery Publishing Limited, Millbank, London, SW1P 4RG

Designed by DED Associates, Sheffield
Printed by Snoeck-Ducaju & Zoon, Belgium

Tate Liverpool, Albert Dock, Liverpool L3 4BB